GHOSTS
OF THE
QUEEN MARY

GHOSTS
OF THE
QUEEN MARY

BRIAN CLUNE WITH BOB DAVIS

Haunted
America

Published by Haunted America
A Division of The History Press
Charleston, SC 29403
www.historypress.net

Front cover: Photograph by Carol M. Highsmith. *Courtesy of the Library of Congress,
Carol M. Highsmith Archive.*
Back cover, top: Authors' private archive.
Back cover, inset: David Twolen.

First published 2014

ISBN 978.1.62619.314.7

Library of Congress CIP data applied for.

Notice: The information in this book is true and complete to the best of our
knowledge. It is offered without guarantee on the part of the authors or The
History Press. The authors and The History Press disclaim all liability in
connection with the use of this book.

Being a paranormal author requires a lot of time away from home and family. I could not do this without the support, inspiration and love of my wonderful wife, Terri. My three fantastic children, sons Carmel and Josh and my sweet pea Amberly, must be without their father on many occasions, and even though they are grown, they will always be my light in the darkness. This book is lovingly dedicated to the four of you. You will always be my muses.

—*Brian Clune*

To my wife, Miyuki; my son, Nick; and my daughter, Katrina. Thank you for always loving and supporting me in all my endeavors. I know the sacrifices you have made so my dream could become a reality.

In addition and equally as important, I would like to give a huge thank-you to my dear friend Brian Clune for enabling our dreams of writing the "Planet Paranormal Guide to the Other Side" book series to become a reality.

Lastly, to Brian's family for putting up with me and letting Brian go on all these research trips that take him away from you. You have no idea how much I appreciate you allowing him to follow his dream, too.

—*Bob Davis*

CONTENTS

FOREWORD

"Jackie, do you like to sing?"
"I do."

Singing, whistling, screams, friendly comments and your unusual curse words…over eight years, those were just some of the disembodied voices and electronic voice phenomena (EVPs) I and others heard during the investigations we performed in the metallic hulls of the *Queen Mary*. The *Queen Mary*, now resting in Long Beach, California, is hardly inactive. Aside from the tourists and overnight visitors who come from all over the world, the ship plays host to many disembodied spirits that call her their permanent home. In fact, the *Queen Mary* is one of my top three most haunted locations I have ever had the pleasure of investigating, and she will always be my all-time favorite.

Let me share with you my background and some of my experiences on this amazing vessel.

In early 2004, during the filming of the first TV show I co-hosted, *Dead Famous*, I had my first opportunity to set foot on the famous ship about which I previously only dreamt. Little did I know that this ship would not only make a great impact on my career but would also reestablish the friendship with the spirit world I once knew as a child. Most importantly, in the years to come, she would also over-deliver on every type of paranormal encounter imaginable—and in front of other witnesses, too.

It began with being introduced to medium Peter James. Peter, who passed away in 2007, was someone I had watched and admired on the television

show *Sightings*. On that show, I had seen him communicate with the ghosts of this very ship. What always amazed me about him, and the show, was that the ghosts actually spoke back to him, for all to hear, on request—and it was captured on film! Now here I was investigating with him.

Every step of the way, I watched intently and listened as Peter called out to the ghosts. His voice echoed off the walls, and I felt like the proverbial kid in a candy store. I was extremely excited. I hoped to experience firsthand the things I saw him do on TV. We were filming this for a show, but I was enthralled with what Peter could show me. I really wanted to see the ghosts of this ship come alive, and oh boy, did they ever!

Near the engine room, Peter called out, "John Henry, can you hear me? Speak to me, John!" Fifteen seconds later, a voice I assumed was John eerily responded, "I hear you."

My skeptical co-host Gail Porter, one of the UK's most well-known pin-up girls and a host of popular shows such as *Tops of the Pops*, thought maybe Peter James was throwing his voice, like a form of ventriloquism. Frustrated with her comment, I felt she was being overly skeptical. This was not the first time her cynical skepticism caused us to butt heads. I was well past the "does it exist?" phase and eager to see the proof. I knew she was on the verge of becoming a believer because a few days earlier, on location at the notoriously haunted Hotel Del Coronado, she had an incredible encounter that dramatically shifted her beliefs. While still emotional and shaken, the *Queen Mary* was probably not the best place for her to explore. However, I couldn't help but be ready if an "I told you so" was in order. I didn't want to appear too smug, but I wouldn't have minded a little bit of vindication. I had spent too many years knowing these things were real not to have wanted some rookies to see what I had been seeing, feeling and hearing since I was a little boy.

The tour guide assigned to assist us with the show led us into the poolroom. We had already been told that the poolroom was the most haunted part of the ship and was considered a portal between this world and the next. Its design made it the perfect spot for this, although I am sure the original designers did not have this in mind. It had two levels of tiled solid walkways and a pool floating dead center. It had a mysterious feel to it, perhaps a result of suggestion, but it also had a definite heavy energy of something dark and foreboding. No amount of suggestion could have caused me to feel the palpable energy. I was used to ghost investigations, but for me, this was the pinnacle, as Everest would be for a rock climber.

Peter called us to gather around him. Gail and the producer said, "Watch his lips," as Peter called out to the spirit of a little girl he called Jackie. After

a few of what we in the ghost hunting business call "baited questions," we heard a response. It was unmistakable and audible to our naked ears.

"Jackie," Peter called. He told us of the many sightings people had of a little girl in this particular part of the ship. Then we heard it, all of us did: it was a distinctive child's voice responding in a playful and singing undertone. It had a distant sound, yet it seemed to be right next to us.

I watched Gail for her reaction. I was expecting her to argue with us and claim some kind of fraud. I am well versed in the trickery people used to employ during the earliest days of spiritualism. Whatever was real was dismissed as a hoax, along with the elaborate schemes used to defraud the hopeful. As much as Houdini devoted his life to debunking the existence of life after death, he also hoped he could find someone who could prove it was true.

I didn't have the skepticism, except when it came to my own sanity at times. It is difficult for a child to live with seeing entities that others can't see. When Jackie's voice was audible to all of us, I saw Gail's expression change. We were all thinking the same thing. There was no way that Peter had been using trickery. No one is that good at ventriloquism. This little girl's spirit touched Gail's heart. Instead of displaying any fear or panic at the realization, Gail began to tear up. I was surprised, but my instincts were to comfort her. I rubbed her back and asked her why she was crying.

"Because," she said, "I heard her. It's so sad for a little girl to be stuck here." With that comment, I knew any skepticism toward Peter or the ship was quickly thrown overboard. It also made me look at things a little differently. In that moment, I, too, realized how lonely it must be for a child to be stuck between the dimensions. Gail changed forever through this ghostly encounter, but so did I.

An hour into our investigation of the poolroom, I saw a dark child-like figure race across the lower deck, just below our crew and my co-host as they filmed a further interview with Peter. I hadn't seen a full ghost apparition like that since my childhood. It was then that I fell in love not only with the ship but also with the ghosts. I can see why this book is being written and why it will continue to quench the thirst for more information about this incredible way station between our world and the world beyond.

Seeing and hearing the ghosts on the *Queen Mary* rekindled my confidence and trust in the spirit world. For the next two hours, I captured remarkable EVPs of Jackie saying, "Hello," as well as other personality-driven spirits responding with friendly and often bizarre comments.

On this day, however, things took a different turn when I entered the shower stalls. There I got pelted with a heavy nut from a bolt. It was so dark

in there that when this metal object came flying out of nowhere and hit my chest, the producer screamed and ran out. This haunted ship has many mysteries, and we can only surmise that not all of the spirits are as sweet and innocent as our singing Jackie.

After I was pelted with the bolt, I was filled with adrenaline; I didn't even think about fear. I had to know who, or what, had thrown it at me. I wasn't sure whether my immediate reaction was the smart one, but it didn't matter. I was hooked on yet another ghostly mystery.

While I never did find out who threw it, I did get some remarkable responses on record just before I left the *Queen Mary* that night. When I said goodbye, I got one response that said, "You'll be back." Then I heard a very angry voice that echoed throughout the pool area. It said, "Get out of here, you f—ing piece of sheet!" This was a good time to take my exit. I thought that maybe this was the thoughtful former person who hit me with a metal nut when I really had no use for one in the dark, cold, damp shower stalls. It comes with the territory. You can't please everyone. I have even had ghostly responses calling me a "dick." I guess they don't always like being disturbed. I do sometimes use annoyance to get them to respond.

The best response—one that I will never forget and have played countless times in my lectures—was when everyone had left, and I was the last person remaining in the room. My producer was telling me, "Come on, Chris. We have to go." I didn't want to leave; my experience on the ship was too incredible for words. I didn't want to lose the connection with this ghostly ground zero. So I looked back on the second level, just before I entered the curtains toward our exit, and said with happiness, love and compassion, "Goodbye, my friends." When I played back my recorder that night in the hotel room, two voices kindly responded, first a male, "Bye," and then a female, "Bye." When I heard them, I knew I needed to come back.

There will never be enough information about the *Queen Mary*. I share my own encounters to whet your appetite for more. I learned from Peter James the love that he had for this ship and his compassion for each and every spirit he communicated with. He respected them, and they, in kind, showed their respect—with few exceptions. I always admired that about the ghosts of the *Queen Mary* and the late Peter James—that special bond they had. It was an honor to investigate the ship alongside one of the greatest psychics to ever walk the walk.

Years later, the EVP prediction "you'll be back" was fulfilled when I was asked to appear at an event on the *Queen Mary*. Darkness Radio Events held a three-day conference that was filled with lectures and ghost hunts.

The first place I had to go was the poolroom. That night on the top balcony, I called out, "Jackie, it's me, Chris. I'm back. Do you remember me?" On the recording, she responded, "Yes," and giggled. Over the years, I heard her sing, heard her shout out and saw her head pop up twice from the second balcony and behind one of the walls, in a peek-a-boo style. One time, I heard a woman yell, "Jackie, get down!" This woman's voice echoed through the pool walls. I wondered if perhaps in that dimension, Jackie and the mystery woman were the ghost hunters and they were unable to perceive me. It was an interesting thought.

Over the years and over four more visits, Jackie and I became friends. She never disappointed, singing or responding while I led groups into the poolroom, startling some people and bringing tears to others. Having your first paranormal experience sometimes does that to you. Luckily, many of these encounters and responses were caught on camera or audio. I felt so at peace in this poolroom. I do need to mention that there was one time Jackie did, in fact, scare the living hell out of me. While one group of twenty-five people left the poolroom to go on to the next location, I was left alone. I was on the second level and changing some batteries on my video camera, which was on a tripod. I felt someone behind me, and I said jokingly, "Jackie, is that you?" Still feeling the presence, I turned around, and a little girl—solid as could be—was standing behind me in a dress that seemed dirty. Her hair was jet black, and her face seemed dirty or dark around the eyes. She had a glaring stare. I nearly stumbled backward. As I began to yell out, "What in the—," she shot backward, quickly breaking down into a mist and flying away from me ever so quickly before taking a sharp left behind the upper balcony walls. Needless to say, I was startled. I had never seen her manifest like that before, complete with details and all. Perhaps she flew away from me due to my reaction. I always wondered, if I didn't react so surprised, whether she would have spoken or stood there longer.

I share my encounters with you to add to the rich stories you will find in this book. The *Queen Mary* is the stuff that legends are made of. I had my own experiences there, but there are innumerable people who can share similar tales. The rich encounters and experiences make the *Queen Mary* what she is today.

When Bob asked me to write the foreword to this book, the first thing I thought of was the time Bob and I crossed paths near the poolroom entrance on the *Queen Mary*. I was there the night he and Brian Clune captured on video a one-on-one conversation with the ghost of Jackie. Their conversation was an amazingly long one using what we call disembodied voices or direct

voice phenomena (DVP). This is not the same as EVP, which can be heard only on playback of a digital recorder. The direct voice phenomenon was live and one on one, like a regular conversation, with no equipment needed. As extraordinary and as rare as it might sound, I was walking in the poolroom when Bob and Brian were walking out, and Bob had the most ridiculous, ecstatic, eyes-wide-open smile from cheek to cheek that you could ever possibly imagine. I first wondered what was wrong with him. Bob barely got the words out: "Incredible…we spoke with Jackie!"

"Cool," I said, not realizing what he truly meant.

"No," he said. "We really had a conversation back and forth."

He got my attention. "Really? Bob, I can't wait to hear it," I said, and hear it I did.

If you haven't heard the actual recording, you need to. Not only is it extremely remarkable, but it is also the same exact child's voice I have on recording back in 2004 and from all visits after that. If you have not heard about it, Bob and Brian will share their story with you in this book. It is incredible—and to think I missed witnessing it by a mere twenty minutes. Look for the actual recording on YouTube.

So once again, when Bob asked me if I would be interested in writing the foreword to his book on the *Queen Mary*, I jumped at the chance. This ship is my favorite place to investigate. For some reason, just like Peter James did, I feel it is like being home. Home to what, you may ask? I am not sure. When people ask me, "Is the *Queen Mary* really haunted?" I say one of two things. My first response is, "Duh!" which is probably not the most intelligent thing to say as a grown adult, but then they haven't been there and have no idea what I have seen and heard. My other remark might be even fresher, and a comment I could imagine even a spirit of the ship would say as well: "Of course she's haunted! Why wouldn't she be?"

Why is the *Queen Mary* haunted? Where did the ghosts come from? What part of her vast history has stayed behind and created the activity we still witness today? These are very important questions. To be able to understand any of that, one must know more about this location and the colorful history and personalities that made the *Queen Mary* what she is.

I never knew much about the *Queen Mary*'s rich history, so I, too, have had similar questions. This book will help answer most—if not all—of them and can satisfy that craving and hunger many of you have had to know more about the stories, legends and mysteries surrounding the world's most haunted ship. But don't worry, when it comes to digging into the history of the *Queen Mary*, not only from an investigative and paranormal perspective

but also from a historical focus, no one but Bob Davis and Brian Clune have shown a greater love or respect for the ship since the late Peter James. For all the times Bob and Brian have investigated the *Queen Mary*, they have not only earned admiration from myself but also from their most important friends on the ship: the very spirits that reside in the metal walls.

I am sure you will enjoy this book, and if you do get a chance to visit the *Queen Mary*, the world's most haunted and active ship, now located in Long Beach, California, remember to call out to her ghostly passengers and say hello to Jackie for me. If you're lucky, she may just sing you a song. By the way, "London Bridge Is Falling Down" is most certainly one of her favorites.

—CHRISTOPHER FLEMING

ACKNOWLEDGEMENTS

We would like to thank all those who have contributed their time and stories to this book. There are so many of you that we hardly know where to begin, and if we have missed anyone, we assure you it is unintentional. We would like to thank Frank Beruecos for writing the awesome tribute to Peter James; Chris Fleming for his wonderful foreword; and especially Dave Twolen, who allowed us the use of his masterful photographic talents, and Gerald Reynolds, who also provided some great ghost pictures.

Thanks go out to Lee Frankel, Joe Hawley, Teri Nixon, Bridget Emery, David A. Gruchow, Joe and Vici Ruffulo, Cornelia Heun-Davidson, Erin Potter, KD Foreman, Jacki Spotts, James and Liz Johnson, Jolene Polyack and Rebecca Ann Fox for submitting some truly eerie tales.

We would also like to thank Michael D. White, Priscilla Uriate, East Valley Paranormal, Donn Shy, Joe and Vici Ruffulo, Ron Yacovetti, Brandon Alvis and APRA, Liz and James Johnson and Dave Hoover for allowing us to use their photographs.

A special thank-you goes out to Tuesday Miles, who has supported us through thick and thin and has always given of herself to allow us to research the *Queen Mary*.

We would also like to thank Rob and Anne Wlodarski for their ongoing efforts to bring to light all of the great sights and haunts of the RMS *Queen Mary* and numerous other locations to the reading public through their many wonderful books. Last but certainly not least, we wish to thank Delia Summerfield for all her years of hard work and dedication. Thank you for keeping everything running smoothly for us!

To the believer, no explanation is necessary, and to the nonbeliever, no explanation is possible.

—*Peter James*

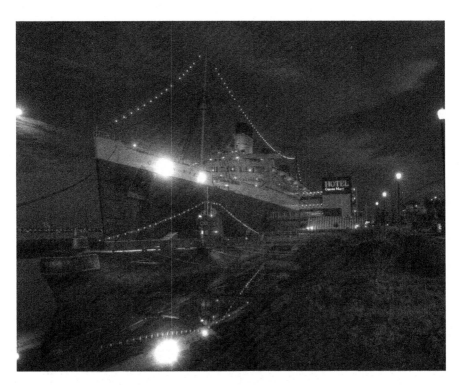

The majestic RMS *Queen Mary. Courtesy of Dave Twolen.*

Chapter 1

THE QUEEN IS CROWNED

R MS *Queen Mary*. You will be hard-pressed to find someone in this world who has not heard of this magnificent ship. If asked, they will tell you that she was a passenger liner from a long time ago, or that she is a hotel somewhere in California, or that she is "that haunted ship" they saw on TV. They may tell you that she is like the *Titanic* or that she is smaller than her older cousin (which she is not), but if you ask them to tell you about the things this ship did or why she is now a tourist attraction, you will most likely get a blank stare. For all her fame and notoriety, people still do not know or understand the *Queen Mary*'s place in history or why it is so important to keep her story alive for the generations that follow us or for those spirits that remain to this day on board the "Stateliest Ship Afloat."

After World War I ended, the North Atlantic passenger trade heated up between the European nations, and Cunard was at the forefront of this new battle. Still sailing its prewar ships but seeing new and faster liners coming from Germany and France, Cunard quickly began designing replacements for its older fleet. It was decided that two large, fast ships would be more economical than the current fleet of smaller vessels, so Cunard sought out perhaps the best shipbuilding company of the day to help design and build its new massive liners, John Brown & Company Shipbuilders.

On December 1, 1930, the first keel plate was laid on job #534, and while not yet known, history itself was being built in the now famous shipyard. Work progressed well on the vessel until the economies of the world began to slow, and when Black Tuesday hit, all work on the ship ceased. Thousands of

shipbuilders were laid off, but two of those men working on job #534 were not seen for three years after the work stopped. Over the intervening years, Cunard worked diligently to get its newest vessel built. Its three aging liners were still in relatively good shape, but the cost of maintenance was exorbitant in the Depression years, and passengers were scarce. Cunard begged the British government for an infusion of money to continue its work, but the Crown wanted Cunard to ally itself with its chief rival, White Star Line, in a bid to save both companies. Finally, in desperation, both of the proud shipping giants agreed, and the Cunard White Star Line was formed.

Work recommenced on the massive hull in April 1934, but as the men started back to work, there was a grim discovery in the bottom sections near the double hull. Two of the men who had been working on the ship when the Depression hit were found dead not too far from each other. Their families had assumed that they had committed suicide after learning they were out of a job, but there was no evidence found to support a case for this. To this day, it is still unclear what happened to these men, but because of the proximity of the corpses and the fact that a welding torch was found near one of the men, it is believed that a buildup of fatal gases may have been the cause. The late Peter James has stated that the spirit we know as "John Henry" is one of these poor men who were found. There is another tale told about a welder who was working between the double hull when he was inadvertently sealed inside and eventually died. It is said that when it was discovered what had happened, the company, with permission from the man's family, had funeral services right there on the ship and left him in the hull as a way to save money and time. The authors believe this to be urban legend but a haunting tale nonetheless.

To this day, guests and investigators report hearing the sound of tapping in the lower sections of the ship. This is most common in the area around what is known as the "Green Room," which is located near the old Boiler Room Stage. It is speculated that these taps and bangs are the crewmen who perished, trying to let us know that they are still on the ship and performing their duties in death as they did in life.

Since the British government was now the major stockholder for the new ship, it required Cunard to give periodic reports to the Crown. Every month, an agent would arrive at the palace with an update on the progress. It was during one of these meetings that the king asked, "And what shall our new ship be named?" Instead of telling the king that Cunard was going to name her RMS *Queen Victoria* as planned, the agent stated, "We are pleased to inform you that Cunard wishes your approval to name our newest and

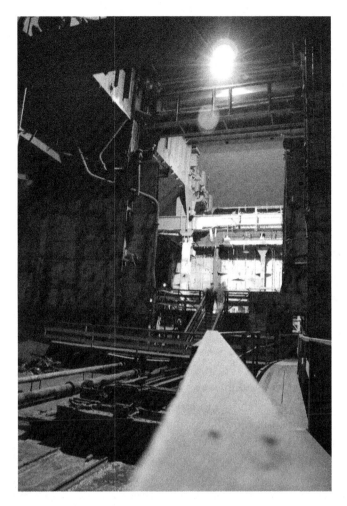

The Boiler Room/Green Room entrance aboard the RMS *Queen Mary. Courtesy of Dave Twolen.*

grandest liner after England's greatest queen." To this, the king responded, "My wife shall be pleased at the compliment, gentlemen." So it was that job #534 was christened RMS *Queen Mary.*

On September 26, 1934, Her Majesty Queen Mary christened job #534, and the grand liner slid into the River Clyde to the cheers of those gathered. She would spend the next twenty months getting fitted out. Cunard spared no expense in the lavish appointments the ship was given, and the most famous artists of the time were commissioned to paint murals, sculpt bas-relief, etch glass and work ornate bronze doors all into a spectacular Art Deco showcase.

The ship had three classes of accommodations, two pools, three nurseries, elevators and entertainment salons for all three classes, and she also served gourmet meals to all passengers, regardless of class. When complete, the RMS *Queen Mary* would truly become the "Stateliest Ship Afloat."

HER SEA TRIALS COMPLETE, the *Queen Mary* set sail on her maiden voyage on May 27, 1936, and it was believed that her captain would try for the coveted Blue Riband, the award for the fastest crossing of the Atlantic. However, thick fog en route dashed any hope of that occurring. Once back in England, the ship was dry-docked briefly for minor adjustments, and on her second westbound voyage, she set a new maritime speed record and won the Riband from her French rival *Normandie*.

Even though *Queen Mary* was new and modern, she was still designed from classic plans and had the characteristics of the older vessels—in other words, she rolled with the waves and quickly gained the nickname "Rolling Mary." This became a problem when, during one of her early voyages, the ship sailed into a storm, and as the liner pitched with the waves, the passengers were tossed about like rag dolls with nothing to hold on to. During the construction of the ship, it was decided that handrails would take away from the aesthetics of the liner, and therefore they were not installed. This oversight allowed many injuries to occur and may have actually caused a little girl to lose her life. The children in third class were fond of sliding down the staircase near the front of the ship and were doing so when the storm hit. A young girl was sliding down the rail when a large wave slammed into the ship and pitched the bow sharply upward. This violent toss caused the child to fall, and she hit the deck hard. When the medical staff arrived, it was found that she had broken her neck, and she was pronounced dead. To this day, there are reports of a spectral child near this staircase that vanishes when approached. The *Queen Mary* was dry-docked following this trip to have handrails installed, and nubbing was placed on any stairway that might be used as a slide in the hopes of preventing any more deaths.

In the following years, the RMS *Queen Mary* sailed without much ado, apart from her rivalry with the French Liner *Normandie*. They would trade the Blue Riband back and forth, with the *Queen Mary* setting the time and then the French vessel recapturing it not long after. This was a time when the North Atlantic route saw its greatest tourist traffic, and the two great liners were the main cause of this. Each ship had her own following, with the RMS *Queen Mary* sailing with such celebrities as Clark Gable, David Niven, Cary Grant and Greta Garbo. Stars weren't the only notaries to sail this route, and she

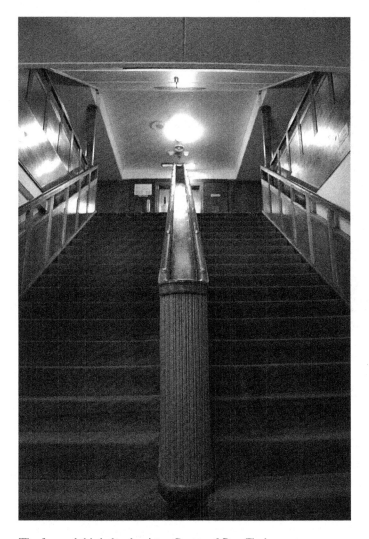

The forward third-class banister. *Courtesy of Dave Twolen.*

would also carry heads of state, such as the Duke and Duchess of Windsor and even the king of England himself.

The storm clouds over Europe were gathering, and Cunard started to notice a rise in immigrant traffic aboard its ships. Even though the *Queen Mary* was now known as a luxury liner, she still had a third-class level, and her well-known auspicious treatment of her passengers meant that she was a favorite for those coming to America to avoid the war everyone thought was about to erupt. She still carried her rich and famous passengers, and so it was

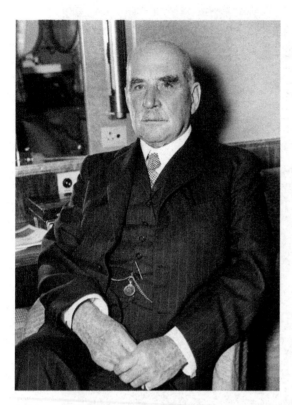

Financier J.P. Morgan. *Courtesy of Acme.*

on September 1, 1939, that the captain of the *Queen Mary* heard about the invasion of Poland by Germany and then, on September 3, was sent a communiqué by Cunard that the English government, along with those of France, Australia and New Zealand, had formally declared war on Hitler and his Reich. When the passengers who were gathered in the grand salon heard the news, they called out, "God save the king!" Bob Hope, who was on that voyage, quietly said in response, "And the *Queen Mary*." Indeed, if it had been known at the time what this magnificent ship was about to do for not only England but also the world, then everyone on board might have stood up and echoed Mr. Hope's words. The RMS *Queen Mary* was about to embark on an adventure that would take her thousands of miles and have her break records that still hold today. She would be hunted, sought after and have a bounty put on her masthead by one of the most powerful and evil men the world has ever known, but she would sail on and laugh in the face of that evil.

Chapter 2

THE GRAY GHOST RISES

Once the RMS *Queen Mary* arrived in New York Harbor on September 4, 1939, her captain was told to stand down and await further orders. The Crown had not yet decided what the fate of the liner would be but deemed it too dangerous to sail back to England with Hitler's U-boats patrolling the Atlantic approaches to the British Isles. It wasn't long before her sister ship RMS *Queen Elizabeth* joined her in port, and the two Cunarders, along with the *Queen Mary*'s longtime rival *Normandie*, sat at wharf awaiting orders. This decision would take months, and while the *Queen Mary* waited, she was slowly being transformed into a sleek gray behemoth capable of carrying thousands of troops to the aid of England. RMS stands for Royal Mail Ship, which meant that the *Queen Mary* and *Queen Elizabeth* were part of the Royal Navy's auxiliary fleet, so it was always a certainty that the two great liners would be called up. What wasn't certain was the job they would be called to do.

While the ships were each receiving their coats of gray paint, most of the fine furnishings were being removed from the *Queen Mary*, and standard troop bunks were being installed. Her portholes were carefully masked so as to emit no light, sandbags were placed around areas deemed "sensitive" and temporary light antiaircraft guns were installed on her decks. A careful cover story was created to fool any German spies who may have been lurking about New York that the *Queen Mary* was to become part of the Canadian Royal Flying Corps training unit, and so it was on March 21, 1940, that the grand liner slipped out of New York Harbor on her way to Sydney, Australia, via Cape Town, South Africa.

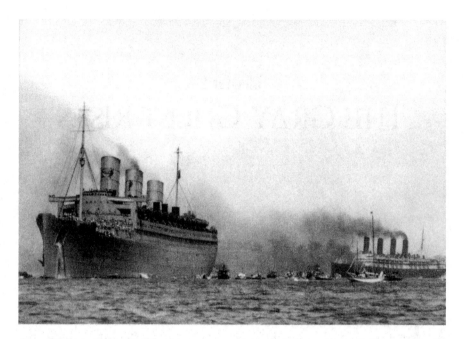

The troop ship HMT *Queen Mary* (foreground) and the RMS *Aquitania* during World War II. *Authors' archive.*

Once the RMS *Queen Mary* arrived in Australia, the real work of converting her to a troop ship commenced. The ship was dry-docked, and the temporary guns were replaced with permanent antiaircraft armament fore and aft. Along the Sun Deck, larger-caliber guns were installed for protection against surface ships and submarines, with one placed far aft and one on either side just below the forward superstructure. While the installation of the defensive weapons was occurring, the rest of the liner's civilian appointments were being removed. Carpets, china, tapestries, deck furniture and any of the decorative woods that could be removed were put into storage. Expanded medical facilities were added, and more bunks were installed, along with hammocks in the areas where bunks wouldn't fit. When the ship finally left the dry dock, there was not one section of the *Queen Mary* that hadn't been redone for her trooping duties.

Her first assignment was to transport 5,500 Australian troops to England to help in the defense of France. The *Queen Mary,* along with several other ships, including three Canadian liners, left Sydney Harbor on May 4 headed for Clyde, Scotland. Hitler invaded westward on May 12; quickly overran Belgium, the Netherlands and Denmark; and made deep advances into

France so quickly that the Allied armies scarcely had time to react. By the time the troops arrived in Scotland, the war in France was all but over, and because the British army had lost all of its tanks, artillery, armored vehicles and many of its men, it was decided that the fresh Australian troops would be used to help bolster the defense of the home islands.

On June 29, 1940, the *Queen Mary* again set sail for the Far East. This time, her destination was the port of Singapore. There she would be dry-docked again for much-needed engine work and the installation of paravanes (devices to cut the cables of explosive mines). Once the work was complete, she again headed to Sydney to gather more troops, but this time, she would be delivering them to India. The *Queen Mary* would spend the next seven months ferrying troops between Bombay, India, and Sydney, Australia, with stops only for repairs and the installation of a degaussing strip. This strip was a device that fed a constant electrical current through the hull, which caused magnetic mines to "ignore" the ship as she passed.

After the Italian army had invaded Egypt, the British managed to push it back deep into Libya. This did not sit well with Hitler, who needed the oil reserves of North Africa to keep his war machine going. To bolster the beleaguered Italians, Germany sent perhaps one of its greatest generals, Erwin Rommel, to take back the lost ground and to capture the oil fields of Egypt and beyond. Once the Desert Fox, as Rommel was known, arrived in the theater, he immediately went on the offensive and began to push the Allied troops back to the very gates of Alexandria, just miles from Cairo. It was clear that England would need more troops to shore up its faltering front lines, and it would need them quickly. The *Queen Mary*, with her large troop-carrying capacity and the fact that she was already close to Australia and New Zealand, was tasked to help save North Africa. On April 9, 1941, the Cunard *Queen* left Sydney Harbor with a full complement of Australian and New Zealand troops, collectively known as Anzacs, and headed for Egypt.

Sailing aboard the *Queen Mary* while in her transformation as a troop ship was uncomfortable at best, but as the ship was built for the North Atlantic transit, certain accommodations were deemed unnecessary and therefore never installed on the liner. Things such as air conditioning and high-capacity ventilation were conspicuously absent. This lack of cooling systems was fine in the cold North Atlantic but could be deadly while transporting troops in the high temperatures of the South Pacific, Indian and Mediterranean Seas. It was not uncommon for the thermometer to hit well above one hundred degrees below decks, and that—coupled with high humidity and insufficient ventilation—caused many men to succumb to heat exhaustion and stroke.

To this day, there is no clear record of how many men—Australian, New Zealand and, later in the war, American—may have perished in this manner, but what is known is that the number is most likely very high.

In November 1941, the *Queen Mary* was on her way to Cape Town, South Africa, and while en route, the Japanese bombed the American Pacific Fleet based at Pearl Harbor, Hawaii. Before the ship even arrived on the continent, the United States had declared war on Japan, Germany and Italy. Knowing that it was just a matter of time before England was brought into the Pacific conflict and knowing that Japan had a large submarine fleet and that Britain had few escorts available in the South Pacific, it was decided to send the *Queen Mary* to the relative safety of New York Harbor to await further orders. The Cunarder arrived on January 12, 1942, but was immediately sent to Boston Harbor to have her troop capacity almost doubled to ten thousand. The first time the *Queen Mary* carried U.S. troops was on February 18, 1942, when she departed New York for Australia on what the GIs dubbed the "forty days and forty nights" cruise. The ship then settled into a routine of sailings from Great Britain to North Africa and New York to Scotland. The RMS *Queen Mary* made history on August 2, 1942, when she sailed with the First Armored Infantry Division on board; this was the first time an entire division had been carried on a single ship.

It was during the *Queen Mary*'s tenure as a troop transport for the U.S. Army that the ship gained her nickname the "Gray Ghost." Hitler began to realize that the sheer size and speed of the liner posed a real threat to the Fatherland and placed a sizable bounty on the ship and her sister, RMS *Queen Elizabeth*. The equivalent of $250,000 and the Iron Cross, Germany's highest military award, would be given to any U-boat captain who could sink the great liners. This task was easier said than done, however. The speed of the average U-boat was only eleven knots surfaced and seven submerged. Later in the war, this was increased to seventeen to twenty-four knots surfaced, still far under the twenty-eight-knot average of the *Queen Mary*. Many a submarine skipper would get the ship in his sights only to watch it steam out of range over the horizon long before the order to fire could be given.

The speed of the *Queen Mary* was such that she would not only outrun the enemy hunting her but also was faster than most of the escorts assigned to protect her. Because of this, early in the war, she was put into convoy with other liners that could come close to matching her speed. However, as the war progressed and Germany built up more and more aircraft designed to hunt and sink British and American shipping, it was decided that as the

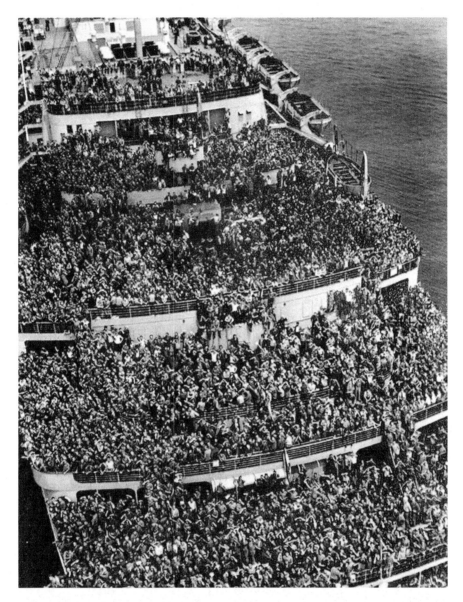

A large number of U.S. troops heading to Europe aboard the *Queen Mary* during World War II. *Authors' archive.*

convoys neared the range of these killers, an escort of antiaircraft cruisers and destroyers would be required. It was on one of these eastbound voyages that the *Queen Mary* would be the cause of one of the worst maritime accidents recorded by the British during World War II.

On October 2, 1942, the Gray Ghost was steaming at a sustained twenty-eight knots in the prescribed zigzag pattern to help evade any U-boats that may have been lurking and was seven hundred miles west of the Irish coast when she spotted her escort fleet coming to meet her convoy. One of these escorts was the HMS *Curacoa*, a light antiaircraft cruiser that was launched in May 1917. As the escorts arrived at the rendezvous with the convoy, they took up their picket stations and began to match the zigzag pattern of the other ships. The *Curacoa* was placed in position near the *Queen Mary* but was steaming closer than necessary. There is some speculation that this was due to the desire of her captain and crew to get pictures of the giant liner as she passed her port side. Whatever the reasons may have been for the escort's nearness to the liner, what happened next will forever be the greatest tragedy the RMS *Queen Mary* will ever know. Trying to match the speed of the *Queen Mary* was difficult at best but impossible while zigzagging. The two ships were so close to each other that when the time came for the liner to start its turn, the *Curacoa* was unable to get out of the way, and the *Queen Mary*'s bow struck the cruiser amidships, slicing it clean in half. To the horror of the GIs on board the liner, the ship didn't even slow as she cut her escort in two but continued on to port. Of the 439 men aboard the HMS *Curacoa*, 338 were lost; however, her captain did survive to face an inquest.

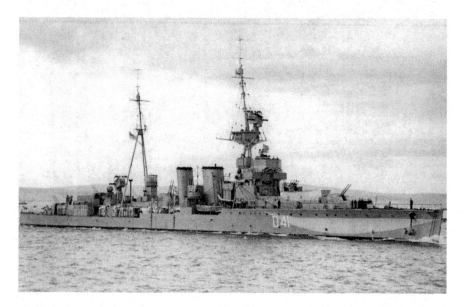

The light cruiser HMS *Curacoa. Authors' archive.*

It is unknown how many of the crew of the *Curacoa* lost their lives to the propellers of the *Queen Mary*, but what is known is that this event left a lingering mark on the grand liner that remains today. Many people have told stories about hearing the screams of men and the rushing of water in the forward areas of the ship. It is a tragedy that the *Queen Mary* has capitalized on by reenacting the event through special effects and gadgetry as part of its Ghosts and Legends tour. All showmanship aside, the men of the gallant HMS *Curacoa* seem to be escorting their charge even today.

Shortly after the incident with the *Curacoa*, the *Queen Mary* narrowly averted another possible disaster when a rogue wave struck the ship. In early December 1942, as the liner approached the Scottish coast, she found herself sailing right into the heart of a gale. The storm was producing some very large waves, and the American troops on board found themselves being tossed about like rag dolls. As the giant ship steamed on, it was suddenly listing at an alarming rate and nearly capsized before the ship finally righted herself. Witnesses have stated that the wave reached a height of ninety-two feet, which caused the *Queen Mary* to list fifty-two degrees, three degrees shy of sending her to the bottom of the Atlantic Ocean. Paul Gallico, a war correspondent at the time, was on board for this event and would later use it as the inspiration for his novel and subsequent movie *The Poseidon Adventure*.

Because the RMS *Queen Mary* sailed primarily between Gourock, Scotland, and New York, it was decided that during her westbound crossings, she would transport German and Italian prisoners of war to American POW camps. Early in the war, these prisoners were held in the forward cargo hold, where the conditions were anything but comfortable. The holds were never designed for human transport, so each person had to share a hammock or bunk to sleep, and the Germans and Italians were not always cordial with one another. Many fights broke out, and this, combined with the sometimes violent motions of the ship, caused many injuries or even deaths. To this day, visitors and paranormal investigators alike report hearing the phantom voices of these long-gone adversaries of democracy when entering the depths of the hold and wonder why these lost men remain. As the war progressed and it appeared that Germany was indeed going to lose, the tensions from the prisoners ebbed, and as a result, the restrictions placed on them eased. They were finally allowed accommodations outside the holds, and there was even a friendly rivalry between the Germans and British in the form of "creative" insults that would appear all over the ship.

In July 1943, the *Queen Mary* set a maritime record that to this day stands alone and will most likely never be broken when she set sail with 15,740

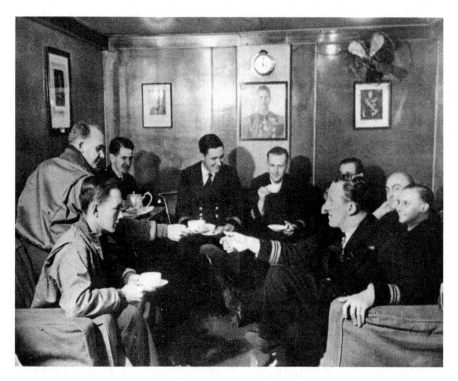

U.S. military officers enjoying teatime on the *Queen Mary* during World War II. *Authors' archive.*

armed troops and a crew of 943 for a grand total of 16,683 souls on board one ship. The soldiers were not comfortable but, for the most part, held their tongues for the five-day crossing from New York and arrived safe and whole in Scotland. The rest of 1943 was basically uneventful, with the exception of the RMS *Queen Mary* transporting one of the most important people in the world at the time, none other than Colonel Warden himself.

Colonel Warden, aka Winston Churchill, sailed on the *Queen Mary* almost exclusively during World War II. Due to the speed of the Cunarder, it was ordered by the Crown that Mr. Churchill sail aboard the *Queen Mary* whenever possible. As a precaution against any spies who may be lurking, he was given the code name Colonel Warden whenever he traveled. Churchill was even given his own lifeboat, replete with a .303 machinegun so as to "resist capture at all costs." It was on one of these crossings that Churchill set into motion one of the greatest campaigns the world would ever know.

The planning for Operation Overlord—D-Day, as we now know it—had progressed to its final stages, and all that was left was for the Allied nations'

leaders to commit to its launch. Churchill was instrumental in the formulation of the plan but still knew his signature on the orders meant that hundreds, if not thousands, of deaths would be on his hands. These deaths he could live with, but only if the invasion of Europe was a success, and that was far from guaranteed. These thoughts and many more ran through his head as he sat at the desk on board the *Queen Mary* in the suite that today bears his name. Churchill, ever the warrior, signed the order and set into motion the invasion of France. He knew that if it were a failure, the war would be prolonged many months—if not years—and that the blood of those who died in vain would be on his hands.

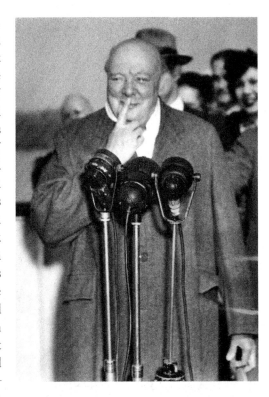

Winston Churchill (Colonel Warden) is seen in this *International News* photo. *Courtesy of Art Abfier.*

It is said that strong emotion can leave an imprint on its surroundings, and what Churchill must have been feeling as he signed those orders would have been among the strongest emotions he felt during his tenure as prime minister. This could be the reason that many visitors to the *Queen Mary* report smelling cigar smoke when they pass by the suite where Churchill's desk remains to this day. Mr. Churchill has also been spotted on the Promenade Deck by the gift shop that was once his onboard office when he sailed and also in the restaurant that bears his name in the aft of the ship. It would seem that the prime minister is still checking up on his favorite liner even to this day. It was his pride in the two Cunarders, *Queen Mary* and *Queen Elizabeth*, that caused him to say, "These two ships, these two Queens of the sea, have managed to shorten the war by a year single-handedly."

The *Queen Mary* left the port of New York the day that the Allies invaded Fortress Europe, and the "great crusade," as Dwight Eisenhower dubbed it, began. The German army fought bravely, and as it was steadily pushed back

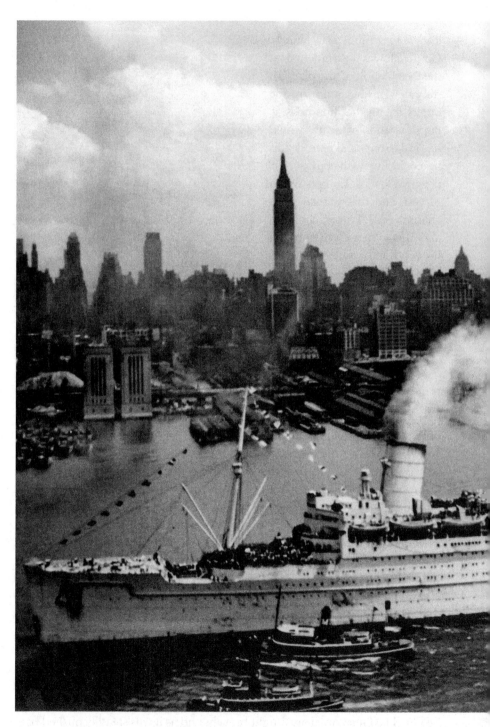

The Gray Ghost arrives in New York Harbor during World War II. *Authors' archive.*

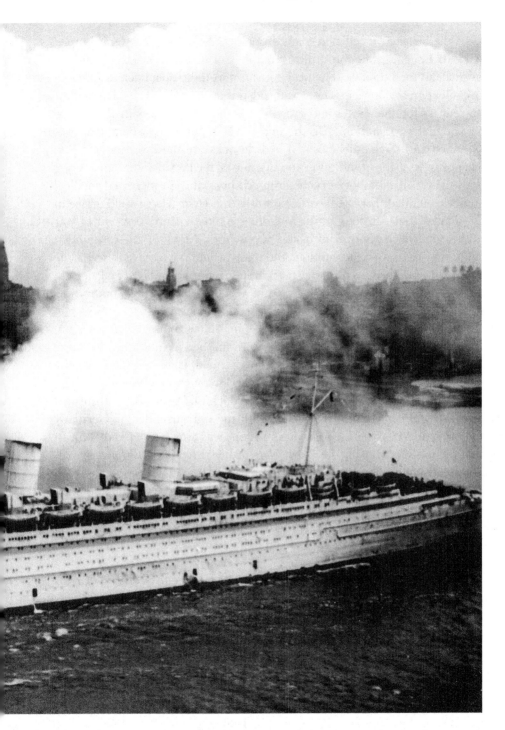

from the beaches, it inflicted many casualties. The wounded were shipped back to England, but the growing number of U.S. servicemen began to overwhelm the hospitals. The need to transport these men back to America became a great concern, so it was decided that the *Queen Mary*, having few passengers for the westbound crossing, should be tasked with the job of returning these men home. To this end, the ship put into port and had over one thousand double-tier hospital beds installed on the Promenade Deck, the port side of the grand salon and in some of the larger staterooms. Along with these beds, a laboratory, separate kitchens and an increased medical staff were added. For the next few months, the *Queen Mary* would arrive in Scotland with new troops for the front lines and then board prisoners of war and wounded GIs and head back to New York. Many of these wounded soldiers were in critical condition, and many would not survive to see home again. The number has never been accurately reported and is not part of the "official" death count reported by Cunard, but one can only wonder how many of these men still remain aboard the ship today.

The *Queen Mary* continued in her trooping duties, but as 1945 wore on, it was clear that Hitler and his Reich were finished. As the need for large amounts of new troops to enter the fray declined, it was decided that the giant Cunarder should be put to dry dock for much-needed repairs. The *Queen Mary* pulled into a New Jersey dry dock on April 18, and thirteen days later, Hitler committed suicide, with the full surrender of Germany following on May 7, 1945. The war in Europe was over, but that didn't mean that the job was over for the *Queen Mary* or her sister *Queen Elizabeth*. Japan was still doggedly fighting in the Pacific and Asia, and the projected losses if the Allies were forced to invade Japan were estimated to be one million men, with the number even higher for the Japanese. This meant that the troops that were not needed for occupation duty in Germany would be sent to the Pacific campaign, and it was decided that the two giant Cunard liners would carry the load.

Once the repairs were complete, *Queen Mary* returned to Scotland. On this trip, however, the ship set a straight course with no zigzagging and her lights ablaze in the evening twilight. With no threat of U-boats, commerce raiders or enemy aircraft to trouble her, the grand liner made the trip in five days and arrived with smiles on her crew members' faces. For the next two months, the *Queen Mary* would load up refugees in New York who were heading home to England—some who had been away for six years—and then embark with a full complement of GIs in Scotland to be delivered back to the United States for redeployment. The liner was still at sea on August 6, 1945, the day

the *Enola Gay* dropped the atomic bomb on the Japanese city of Hiroshima, and then three days later, when the city of Nagasaki was obliterated. On August 14, as the *Queen Mary* was getting ready to set sail with another load of U.S. troops heading home, word came of the unconditional surrender of the Japanese Empire. After six years of war and countless millions dead, the most destructive conflict in human history was finally at an end.

THE WAR MAY HAVE been over, but that didn't mean that the task of getting thousands of GIs home to America was at its end. The United States and Great Britain agreed that the best way to accomplish this would be to keep the *Queen Mary* and her sister *Queen Elizabeth* in the hands of the U.S. Maritime Service. For the next few months, the *Queen Mary*'s sole job was the repatriation of American soldiers from foreign battlefields. Once the bulk of those servicemen were home, the job changed to one that would become a joy for all involved and help bring a sense of normalcy to the crew of the grand old liner—reuniting European wives with their American husbands.

On January 14, 1946, the RMS *Queen Mary* entered the King George V graving dock for extensive cosmetic work. Over the next sixteen days, the ship was stripped of all of her remaining hardware and weapons. Her armor was removed, as were the paravanes that had been installed, but because of the threat of the thousands of magnetic mines still floating about the world's waterways, it was decided to keep the degaussing strips in place. Over the war years, with thousands of troops from many different countries embarking, many of these men passed the time on the voyages by scrawling their names, hometowns and other more colorful bits of speech into the woodwork and wooden railings on board the ship. Wanting to make sure that the women and children would not be embarrassed, all of the marked railings were removed, and temporary replacements were installed. Sailors scrubbed any surface they found with graffiti, while other areas had to be sanded and scraped or painted to make sure anything that could be found offensive was gone from the ship.

Cunard had made arrangements during the war to have the *Queen Mary*'s furnishings brought back to England to be stored in warehouses. Some of these were now reinstalled on the liner, with six comfortable beds in each stateroom, and special rooms for expectant mothers with call bells, which rang directly to the hospital ward, were added. The troop mess halls were transformed back into dining rooms, and many of the meeting areas were restored to their prewar configurations. Even the shops on the promenade were reopened, all in a bid to make the voyage as comfortable as possible

for her new passengers. While the common areas were undergoing the transformation back to a semblance of normalcy, the lower areas were also receiving attention. The machinery was getting much-needed repairs, rusted and worn fittings were replaced and the hull was scraped where it was needed. By the end of January, the RMS *Queen Mary* was ready for her brides and their babies.

February 5 was cold and cloudy, but that did not dampen the spirits of those gathered in front of the immigration and customs units that would clear the war brides to be transported to their new homes in America. The voyage would take five days, and the passengers' time was used in lectures on life in the United States, including history, politics, budgetary practices and childcare. The older children were treated to tours of the ship, which showed them how the bridge, engine room and other important areas worked, and the smaller children played the day away in brand-new nurseries and playrooms. It is the authors' belief that one of the most famous spirits on board the ship comes from this period in the *Queen Mary*'s history. We are referring to the little ghost girl we know as Jackie. Many of the records from this time are lost, and Jackie's origin is not known, so it seems likely that this sweet little child comes from this time. What is known, however, is that she does exist and is quite vocal in letting people know that she is still here looking for her mother.

America ended its bride-and-baby cruises on April 22, 1946, nine days before the agreed-upon date of May 1. Between that time and February, the *Queen Mary* had transported 12,200 dependents and steamed 31,800 nautical miles in five crossings—all while dealing with a fuel shortage in England. Next came the Canadian segment of her dependent voyages. This portion would take an additional four months, cover 51,000 miles and carry 19,000 dependents and average 2,200 passengers per westbound cruise. The last bride-and-baby voyage took place in September 1946, and the Ministry of War informed Cunard White Star that when the ship arrived back in Southampton later that month, she would be turned back over to the company to resume her career as a passenger liner. When the RMS *Queen Mary* arrived in England, it was to a cheering and grateful crowd waving flags and playing the national anthem. As she pulled up to the dock, tears rolled down the cheeks of the people who knew all too well what the *Queen Mary* and her sister *Queen Elizabeth* had given to the freedom of not only Great Britain but to the world as well.

When World War II ended, no other ship in any navy had done more to help hasten the end of hostilities. The *Queen Mary* alone had played a part

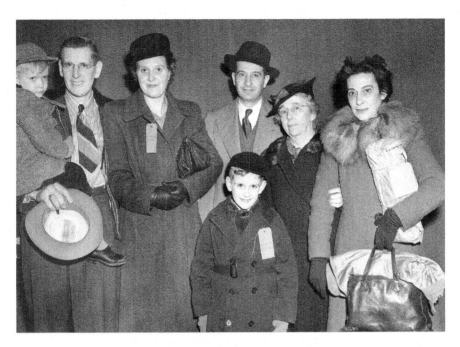

War brides and children arrive in New York. *Courtesy of Acme.*

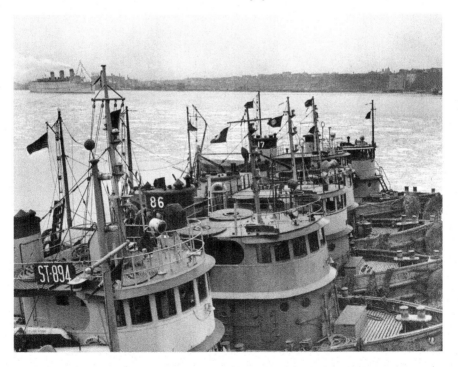

The *Queen Mary* pulls into harbor on another war bride cruise. *Courtesy of Acme.*

in every major campaign of the European theater of operations, as well as in the defense of Singapore and North Africa. She became the first ship in history to carry ten thousand people in a single voyage, the first to carry a fully equipped army division and the only ship still to this date to carry over sixteen thousand passengers on a single voyage—all while being hunted by the combined forces of Germany, Italy and Japan. In all her time at war, sailing 600,000 nautical miles and with a bounty on her head, the RMS *Queen Mary* was never fired on, never fired her guns in anger and never lost a single passenger to enemy action. She truly was the Gray Ghost.

Chapter 3
THE QUEEN'S GOLDEN AGE

With her war service at an end, the *Queen Mary* was now free to resume her career as the premier sailing ship of the North Atlantic, but six and a half years of war, with scant time for repairs and constant hard sailing, had taken their toll on the once beautiful liner. Like her sister ship the *Queen Elizabeth*, when she was demilitarized the previous March, the *Queen Mary* had required a complete renovation before she could resume regular service between Southampton and New York. This refurbishment began within ten days of her arrival back in England and took just over ten months to complete.

The first stop for the *Queen Mary* was the King George V graving dock. Here her engines, powerful but long overworked, underwent their first comprehensive overhaul since 1939. While the work on her engines was being done, the part of her bow that had been damaged during the HMS *Curacao* tragedy and repaired with a temporary piece while in Boston was finally replaced with a new permanent prow section. At the same time, her hull was scraped and repainted. Thousands of workers labored day and night to remove the many scars left by her time at war. All of her public areas, as well as her cabins, were completely restored; her decks and railings were resurfaced; new carpets were installed throughout the ship; and all of the exotic woods and artworks that had languished in warehouses during the war were now back where they could be enjoyed by the passengers. Some of the changes that occurred on the ship during her refit included adding projectors to some of the ballrooms, which allowed them to be dual purposed, along with new murals and paintings to "make the atmosphere

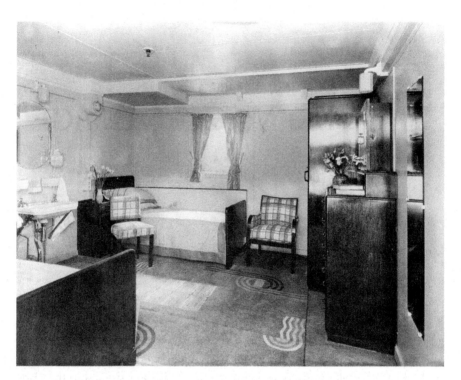

A tourist-class stateroom aboard the ship. *Courtesy of Cunard White Star.*

gay and the colors vivid," as Cunard liked to say. All the crew quarters were updated and improved. The biggest change, however, came in the form of reorganization of the passenger cabins. The new configuration consisted of 711 first-class staterooms, 707 second-class rooms and 577 cabins for third-class passengers.

One thing that did not change was Cunard's commitment to service for its passengers. Nowhere is this more evident than in *Queen Mary*'s dining rooms. Since there were still three separate and distinct classes on board, that meant three dining rooms and three menus for each meal, or 1,904 menus per meal, for a total of 5,712 each day. These did not include the menus for the exclusive Veranda Grill. To this end and for all of the other myriad programs, notices and other ship's flyers needed on a daily basis, the *Queen Mary* had her own printing press on board. This department was able to produce lovely menus each day and often used images of the wonderful artwork spread throughout the ship. Each passenger, regardless of class, was treated to the same level of service, with the only difference being available choices. The menus for each class offered many selections, but there were

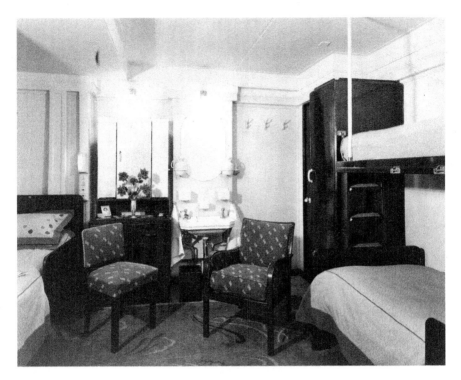

Second-class stateroom on the *Queen Mary. Courtesy of Cunard White Star.*

more choices in second and even more in first class. As an example, the first-class menu offered ten fruits and three fruit juices; eleven cereals; four fish entrées; six egg dishes and omelets made to order; three potato styles; pancakes; waffles; six grill meats, as well as cold meats and salads; seven breads, including a wide selection of marmalades, jams, honey and butter; and, of course, coffee, tea and hot chocolate. Second-class passengers were offered a lot of these as well, but the choices diminished by a wide margin in third class. One thing that set the *Queen Mary* apart was the fact that any passenger could order a special meal, and somehow the chef would find the ingredients and prepare the dish to the exact order for the guest. Not only were the choices different for each class, but the separate dining rooms also had their own distinct patterns of china, silverware, glassware, serving pieces and linens. The Veranda Grill was an exclusive dining area for the affluent passengers, and it carried a menu all its own and allowed passengers a more intimate dining experience. Once dinner was over, however, the Veranda Grill was transformed into a dancing venue, where the rich and famous could be seen and admired by all.

Original postcard. *Courtesy of Cunard White Star.*

As a note, there is a tale widely circulated about a spectral cook or a chef, possibly a mess cook during World War II, who was so hated—or who served chipped beef one too many times—that he was shoved into an oven and cooked to death by an angry crew of irate GIs. As this would have been a very open act and could not have been easily hidden from other passengers or GI officers, along with the fact that there is no credible account of this incident anywhere to be found, it is the authors' belief that this story is just urban legend told to scare guests and fool gullible ghost hunters. However, there may be a real connection on how this story came about, which will be told later.

As much as Cunard tried to re-create the feel and glamour of *Queen Mary*'s pre–World War II elegance, the company also wanted her passengers to know that Cunard was forward thinking. To this end, florescent lights were removed in certain areas and replaced by incandescent bulbs. The new "Regent Street" shopping area looked more like a commercial marketplace, and even some of the rooms (mostly those in third class) began to look almost manufactured. When the work was completed in July 1947, she had been thoroughly refurbished inside and out. Now painted in her fresh

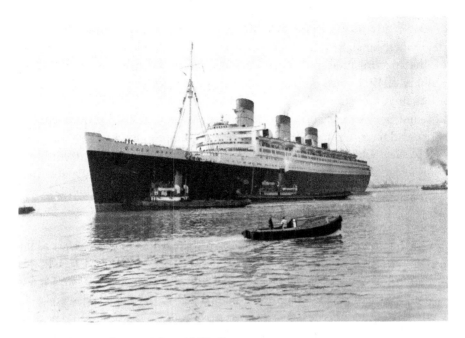

Original postcard. *Courtesy of Cunard White Star.*

Cunard red, white and black colors, she once again took up the mantle as the "Stateliest Ship Afloat." When the *Queen Mary* sailed on July 31, 1947, Cunard finally realized its dream of 1926 to have a two-ship relay between Southampton and New York. This dual transit could not have come at a better time; France and the United States had already begun to have weekly sailings from New York to Europe, and Cunard was hard pressed to keep its profit margins intact with only the *Queen Elizabeth* making the fast crossing. Even though *Mauritania*, *Aquitania* and others in the fleet were still making the run, they did not have the capacity, speed or elegance of the *Queen Mary* or her rivals.

Cunard had its twice-weekly service, but as with any endeavor, things can and will go awry. Just a month after the *Queen Mary* sailed on her renewed passenger schedule, a German prisoner of war, Martin Georg Eppich, escaped from captivity and made his way to Southampton, where he spotted the *Queen Mary* getting ready to sail. He stowed away on board and made it to New York. Once in the States, he located some relatives with the idea of starting a new life but was turned over to authorities by those same relatives and was deported back. This incident, however, became an embarrassment not only for Cunard but also for England. Then, in October 1948, while

47

getting ready to sail from New York, her third officer, Thomas Marshall, died when he slipped and fell while climbing a ladder. Could he be one of the spectral crew members we see walking the decks even today? In January 1949, the *Queen Mary* was departing Cherbourg when she snagged a forgotten anti-submarine cable, and while trying to get free, she was run aground by a strong gust of wind. The damage to the ship was such that she would have to put back into port at Southampton for temporary repairs before she could sail on to New York. Cunard made arrangements for other ships to carry the *Queen Mary*'s passengers, but many had already made their own arrangements to fly back from France. This simple change in plans was an omen of things to come for the ocean liner passenger trade, as the Jet Age was about to begin.

One of the biggest events in the postwar career for the *Queen Mary* as far as her American admirers were concerned happened in July 1948. It was announced that passengers boarding the ship were only allowed two friends each to see them off and that they would have to carry special passes as well. Cunard instituted this new rule because thousands of "guests" would flock to board the ship in New York to see passengers off, even though many of these didn't actually know a departing traveler. There were so many, in fact, that the crew was hard pressed to get the luggage to the assigned cabins in time for sailing. Passengers would have to try to squeeze down corridors, unable to see the room numbers and inconvenienced to the point of discomfort. There were occasions where the visitors outnumbered the passengers by a six to one margin. Since the *Queen Mary* could carry two thousand passengers in a single sailing, one can imagine the crowd that could gather. These guests would sometimes have impromptu parties, causing even greater confusion, which would oftentimes leave visitors on board long after the ship would sail. These "stowaways" would then have to be rounded up and put ashore by motor launch, which caused Cunard and the City of New York not only headaches but also the loss of hundreds of dollars.

In 1953, the winds of change began to blow for the great liners of the oceans as new technology in aircraft manufacturing was growing rapidly, and the cost of maintaining and provisioning the large ships was rising as well. The McCarran Act had come into being the year before in the United States to "stop the spread of Communism," which put a strain on the crew of the *Queen Mary*, as well as the relations between the two nations. Following the day in which Captain Sorrell brilliantly docked the *Queen Mary* in New York without the aid of tugs, the ship was accused of expelling too much black smoke while docking and was warned that if it

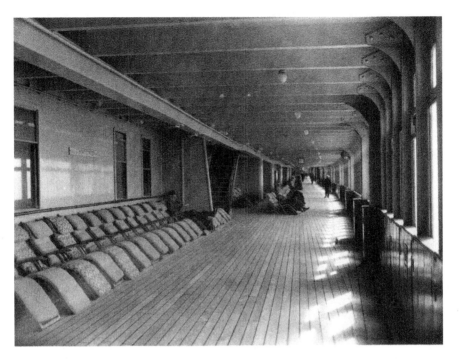

Original postcard. *Courtesy of Cunard White Star.*

happened again, it would be charged up to $100 by the New York City Board of Air Pollution.

Captain Sorrell was again involved in a tense situation a couple years later, but this one had life-or-death consequences to it, as well as possible ship damages. In January 1955, the *Queen Mary* received a distress call from the Panamanian ship *Liberator.* Two of the crew members of the *Liberator* had fallen down a hatch and were "mortally wounded," as the radio message stated. It took a master's skill to position the *Queen Mary* to protect the liner's lifeboat while in transit and keeping it in position while the injured men were hoisted aboard, but it was the bravery shown by the two crews of the lifeboat and the ship's doctor that prove that even a floating hotel still needs experienced and brave seamen to keep its charges safe from the perils of the ocean.

For years, the *Queen Mary* had been known as "Rolling Mary" due to her penchant to sway from side to side in rough seas. As was mentioned in an earlier chapter, this could cause both passengers and crew members alike not only discomfort but possible injuries as well. In one crossing in 1954, the ship went through a gale, which caused numerous broken bones among the

Original postcard. *Courtesy of Cunard White Star.*

passengers and forced actress June Havoc to have to explain why her ankles were bruised when disembarking. She told the press, "Both of my ankles are black and blue from rolling champagne bottles. A bunch of us were in the Veranda Grill when a hurricane struck. It sobered us up considerably." The Queen Mother was also on board for this crossing, which caused the Cunard Company to start planning for the instillation of stabilizers. The engineering required to accommodate the stabilizers on a ship like the *Queen Mary*, where every inch of space was already taken up with machinery, was daunting, but eventually this problem was solved. In 1958, the ship was removed from service for eighteen months, and when she again emerged, two Denny Brown stabilizers, each with two fins, could be deployed, which could steady the giant liner in as little as thirty-five seconds.

The year 1958 was the one when Boeing 707 jetliners began regular service across the North Atlantic routes. In 1953, 38 percent of transatlantic passengers flew, but that number had grown to 68 percent by 1958 and would reach 95 percent by 1965. The American SS *United States* had wrested control of the Blue Riband from the *Queen Mary* in July 1952, and many of the passengers who had sailed with Cunard were now choosing to sail on

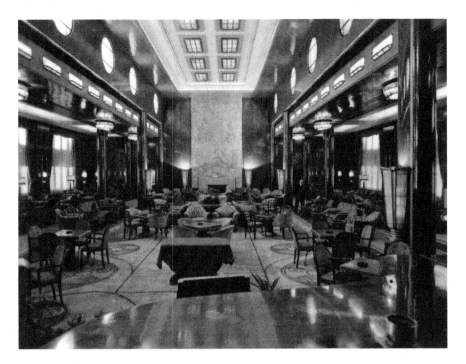

Original postcard. *Courtesy of Cunard White Star.*

the newer, faster American ship. The *Queen Mary* and *Queen Elizabeth* still had loyal followers, but it was clear that the time of grand liner travel was waning fast. As 1959 dawned, talk had begun in the offices of Cunard and the halls of Parliament about replacing the aging Queens, but as no decision was forthcoming, the ships did as they always had—persevered and kept right on sailing.

When the *Queen Mary* docked in Southampton on November 13, 1961, she had a guest capacity of just over 2,000; however, she arrived with just 437 passengers. It was the first time since World War II that only one train was needed to get the travelers to Waterloo, but unfortunately, this was a trend that would be repeated many times. As the passenger list declined, Cunard scrambled to find ways to lure more customers to travel on the *Queens* and so expanded their itineraries. The *Queen Mary* sailed to the Canaries and back at the end of 1963, the first time since the end of the war, and by 1965, plans were in the works to have the two ships cruise to the Bahamas. The problem with these cruises was that both the *Queen Mary* and her sister *Queen Elizabeth* were both designed with the cold North Atlantic in mind and therefore were not equipped with central air conditioning, and neither ship had the

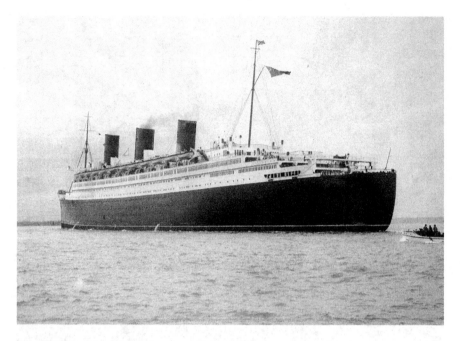

The *Queen Mary* departs Southampton. *Authors' archive.*

amenities, such as above-deck pools, that the newer ships, built for this type of sailing, were designed with. This made for some uncomfortable passengers, and these cruises were discontinued after a short time in existence.

People's attitudes began to change in regard to liner travel as "cruising" became popular. This new wave of sailing for vacation rather than as a way to get to your vacation, along with the growing popularity of air travel, began to cost Cunard millions of pounds each year as its passenger lists grew smaller and smaller. By the time 1966 had come to an end, it was common for the Queens to arrive in port with more crew than passengers on board. The company knew that this trend was unsustainable, and since the keel for the *Queen Mary*'s replacement had already been laid down, the company made the decision to retire the great liners. So it was on the morning of May 8, 1967, that Captain William Law was told by radio to open a sealed letter in his possession; after silently reading its contents to himself, he turned to his department heads and read it to them. "The RMS *Queen Mary*," it said, "will be retired in the autumn." The crew stoically received the not-unexpected news, nodded and returned to their duties. A similar envelope was opened on board the *Queen Elizabeth,* but when her captain read that the ship was to be retired a year after her sister, the crew members were in a state of shock; it

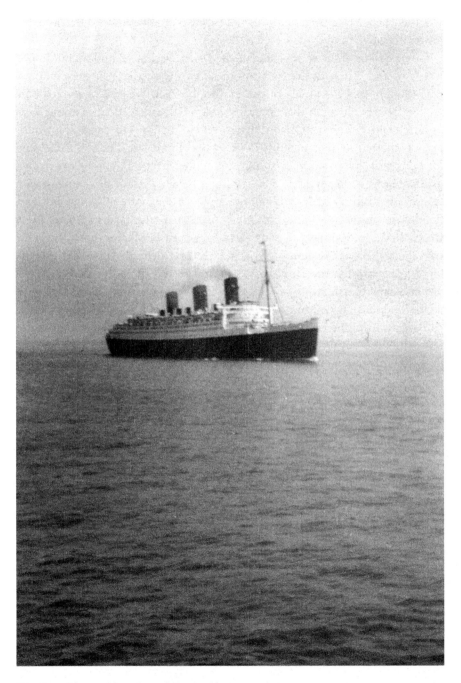

The *Queen Mary* cruising along. *Authors' archive.*

was their belief that their ship was not expected to be removed from service for another five to ten years.

Cunard figured the scrap value of the *Queen Mary* at $2 million but hoped to get more by putting her out to bid. There were those in the company who thought this was an ill-conceived idea, but as those bids began to come in, they slowly changed their minds. Some of the ideas floated about were as farfetched as the two Queens being welded together to create the worlds largest catamaran, permanently docking the ship in the Thames to be used for housing London's homeless and sinking her in the Bahamas to create a fish hatchery. In the end, the City of Long Beach, California, came in with the winning bid of $3.45 million and a plan to permanently dock her as a floating maritime museum and hotel. As part of the terms of sale, Long Beach had the option of having passengers cruise on the final voyage or pay Cunard the equivalent of costs incurred for delivery. The ship was too large to fit through the Panama Canal and would therefore have to travel around Cape Horn, cross the equator twice and sail between ports that were in the tropics—all without air conditioning. Cunard tried to dissuade the Americans from the passenger option, but to no avail, so Cunard refused to book the final voyage. In the end, the Fugazy Travel Agency was hired to make the arrangements, and the RMS *Queen Mary* was set to come to her new home in America.

Chapter 4
THE VOYAGE HOME

E ven though Cunard had tried to convince the *Queen Mary*'s new owners not to engage passengers for the final voyage of the grand liner, the City of Long Beach, California, did not want to see its prize sail into port as an empty ship with only crew and no passengers to celebrate once she arrived at her new home. There were also monetary concerns, as Long Beach would be required to compensate Cunard for costs incurred for delivery if there were no paying fares. The *Queen Mary* made one final cruise to the Canaries and then put into Southampton for the last time to prepare for her final voyage to the United States. RMS *Queen Mary*, in her thirty-one years, had crossed the Atlantic 1,001 times, steamed 3,794,017 nautical miles and had carried over 2,115,000 passengers.

On October 31, 1967, at 9:42 a.m., the Grand Dame of the seas pulled away from her Southampton dock to the cheers of a vast crowed and the Royal Marine band playing "Auld Lang Syne." As she pulled into the channel, she was met by an armada of small boats, ships and vessels of every size and escorted by fourteen Royal Navy helicopters in anchor formation. From the *Queen Mary*'s mast flew her 310-foot "paying-off" pennant signifying her removal from service with ten feet of length for every year of service life. On board for this final crossing were 1,040 passengers but only 860 crew members out of the 1,100 who were normally required for the standard of service for which Cunard was known.

Only two of the ship's four engines were to be used for this voyage to conserve fuel for the 14,559-mile transit. This gave the ship only a twenty-

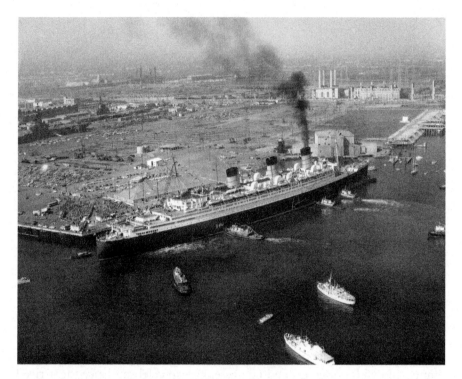

The *Queen Mary* guided by tugs into Long Beach. *Courtesy of Harry Merrick.*

two-knot speed. Cunard had not taken into account the weather or the drag that two unused propellers would have on the ship, and so the speed was reduced even further. The *Queen Mary*'s first port of call was Lisbon, and the draft of the ship was such that she could enter port only at high tide. Because of the miscalculation in speed, it was determined that the liner would miss her opportunity and would have to wait twelve hours for the next tide to come in. The decision was made to slow the ship even further so as to time her arrival with the next tide instead of stopping and having to explain to the passengers the reason for the wait. This was the first in a long line of mishaps and misfortunes that awaited the passengers and crew on this last great cruise.

Las Palmas was the next stop and then across the Atlantic to Rio de Janeiro, a 3,500-mile trek in tropical heat on a ship made for the North Atlantic. Most of the passengers aboard were elderly, and they had to endure sweltering heat in cabins that had only fans to cool them off. The public areas were even worse. Crowds would gather for meals only to leave quickly as the heat from the outside air mixed with the heat of the gathering

diners. If the passengers were uncomfortable, the crew working below decks and behind the scenes were even worse off. The heat got so bad that many of the crew had to be relieved every so often to cool off before resuming their duties. So bad was it in the kitchens that one assistant chef collapsed from the heat and could not be revived. The man was taken to the hospital, where he was packed in ice to bring down his core temperature, but he still died from heat stroke before the ice could work. He was buried at sea with his "mates" at his side. He was the only one to have died on this voyage, although most—if not all—of the crew did get heat sickness to some degree.

As a note, the assistant chef could be the cause of the stories that have persisted over the years of a spectral cook seen on the *Queen Mary*. It is well known that seamen can have a penchant for telling stories, and the fact that their friend died on a voyage they thought should not have taken place could have sparked the tales. The story was passed along, and as we all know happens, each retelling could have added features until the story grew to what we know it to be today.

The stopover in Rio de Janeiro was scheduled for three days, and many of the wealthy passengers decided not to stay on the ship but headed for air-conditioned hotels in town instead. One elderly couple had decided that they had had enough and decided to catch the first flight home to Long Beach. Once they arrived home, they told the press, "The *Queen Mary* was a nightmare of rats and cockroaches." After she arrived in Long Beach, however, she was inspected and given a clean bill of health.

Once Rio was behind the ship, the weather started to change drastically. As the *Queen Mary* headed farther south, it became necessary to heat the cabins, and by the time the ship sighted the Falkland Islands, ice was beginning to form on her decks. As she came into sight of Cape Horn, an icy rain was falling, but that did nothing to dissuade the passengers from gathering on deck to watch. While the ship was made ready in Southampton, two bright red double-decker buses had been loaded aboard ship to be used as promotions. A doctor sailing on the ship came up with the idea to sell tickets to the other passengers to "ride" on the buses around the Cape. The buses sold out, and all the money was donated to an orphanage in Valparaiso, the *Queen Mary*'s next port of call. The weather was calm as the ship rounded the Cape and held until the following day when she ran into a raging gale. The ship was rocked and buffeted but finally made it safely to Valparaiso, the first ever Pacific port for the *Queen Mary*.

In Chile, the mayor of Long Beach, Edwin Wade, came on board, and in Acapulco, the press corps arrived. The ship was again heating up, and the only

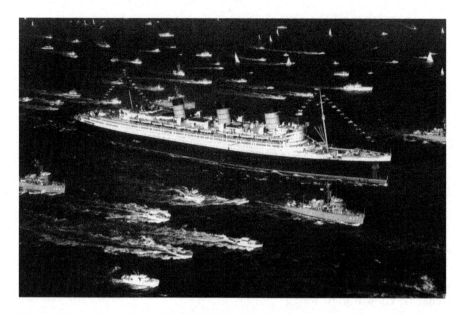

The *Queen Mary* arrives in Long Beach on December 9, 1967. *Courtesy of Michael D. White.*

cabins available for the sixty reporters were below on C and D decks. The press was not kind as they sent word that the passengers were complaining about shoddy service, poor food and intolerable heat and cold, and one English reporter's headline stated, "The Queen that Died of Shame."

Regardless of the trials endured by the passengers and crew members of the *Queen Mary* on her final voyage, California was eager to greet her. While still many miles from port, an aircraft flew over and rained fresh chrysanthemums and carnations over her deck. As she approached within sixty-five miles, yachts, barges, cabin cruisers and other small vessels came to follow her in, a skywriting plane wrote out "Hail the Queen" and, as she entered port, Coast Guard cutters took up their places and escorted her the rest of the way. The USS *Bennington* had draped a streamer along her flight deck that said, "Welcome Queen Mary." Just after 11:00 a.m. on December 9, 1967, the RMS *Queen Mary* was tied to the dock in Long Beach. Captain J. Treasure Jones handed the mayor of Long Beach the Cunard house flag and her Blue Ensign, and then two days later, the ship was formally handed over to the city, removed from the Register of Ships and stricken from Lloyds of London. RMS *Queen Mary*, the ship that saw the world change, had carried the rich and famous and had helped defeat the combined might of the Axis powers, had sailed her last mile.

THE RE-BERTH OF
A LEGEND

The conversion of the RMS *Queen Mary* from an oceangoing vessel to a tourist attraction was a monumental task. All of the remaining fuel needed to be removed, any loose flammable materiel discarded and the ship dry docked. The only facility large enough to handle the ship was the Long Beach Naval shipyard, so the *Queen Mary* was towed there and the work began to make her a building. The liner was sandblasted, sealed and repainted. Her forward engine room was removed, as were all of her boiler rooms, generator rooms, water-softening plants and the Denny-Brown stabilizers. An estimated 320 tons of paint were removed from the ship, which raised her water line by a full one and a half inches. To facilitate the removal of her boilers and engines, it had been decided to remove the ship's three funnels. It was found during this operation that the condition of the stacks was such that the main thing holding them together were the thirty coats of paint that had been applied over the years; subsequently, the decision was made to replace them with new aluminum funnels.

The interiors of the ship underwent changes that make the grand liner's days at sea all but unrecognizable. All of the decks below R deck (C deck before 1950) had been completely gutted to make way for the museum. R deck itself was changed by dividing the first-class dining room into two separate banquet areas; the second-class dining room was subdivided into kitchen space, an employee break room and storage; and the third-class dining room was removed completely and given over solely to storage. The Turkish baths, once the pride of Cunard, were removed, as was the second-

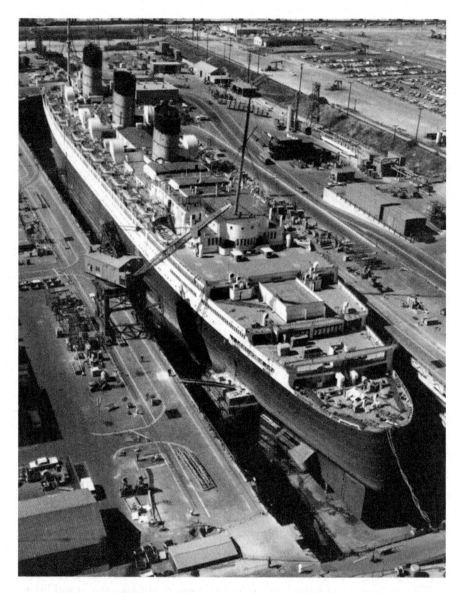

The *Queen Mary* dry-docked for conversion to a tourist attraction. *Courtesy of Michael D. White.*

class bathing pool. The first-class pool was retained for use by hotel guests but was later found to be in violation of safety standards, and a question had arisen about its structural stability, so it was eventually drained and has remained so ever since. The first-class cinema was removed and turned into extra kitchen space, and the first-class lounge and smoking rooms were

converted to banquet rooms, while the second-class smoking room became a wedding chapel and offices. The tastefully appointed Observation Bar was sadly redone in a western motif, and the elegant Veranda Grill was gutted and made into a fast-food venue. All of the smaller rooms, like the library and music room, were converted into retail space, and the sun deck also had many areas converted to retail and concessions.

The sections of the ship that were changed the least were the areas and rooms on M, A and B decks. These were the rooms that were used for the hotel. Most of the first- and second-class rooms on these decks became the hotel rooms and were converted only by adding modern amenities that would be found in any upscale hotel room. The foyer that greeted passengers became the hotel entrance, and the Pursers Office was transformed into the registration desk. Four hundred rooms were envisioned for the hotel, so some of the rooms had to be redesigned to make this a reality. All of the suites on the ship were named after someone important who sailed on her in her career, such as the Duke and Duchess of Windsor Suite or the Winston Churchill Suite.

While the conversion was taking place, a dispute erupted between the unions of the land-based contractors and the maritime contractors who were working on the ship. Each wanted to know where their responsibilities lay and would not go back to work until the dispute was settled on whether the *Queen Mary* was still classified as a ship. The United States Coast Guard stepped in and declared that since the liner was no longer seaworthy; had no working boilers, propellers or engines; and a hole had been cut into the hull to display her remaining propeller, it would now be classified as a building. This decision had the added benefit of removing the liner from the responsibility of the Coast Guard and transferring it to the city fire department.

The *Queen Mary* started her new career as a tourist attraction on May 8, 1971, and the much-anticipated Jacques Cousteau's Museum of the Sea opened the following December but with only a quarter of its planned exhibits. The initial reaction to the ship was one of awe, and people flocked to see her. Their enthusiasm was tempered by the fact that many of the attractions were not yet accessible, and not all of the restaurants or the hotel had been opened. The hotel finally opened its doors in November 1972 but had only 150 rooms available. Diners Club could not seem to figure out how to run the attraction, and the ship began to lose money almost immediately. In 1974, Hyatt took over hotel operations, but the ship continued to spiral down, Jacques Cousteau's Museum could not keep its fish from dying and

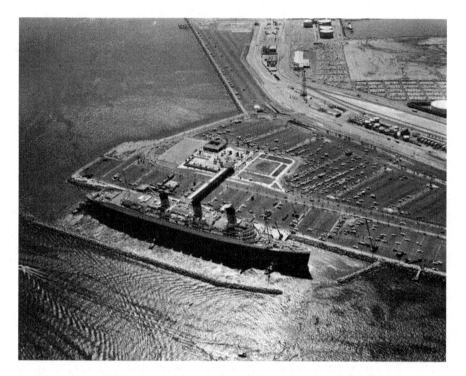

The *Queen Mary* at her new permanent home. *Courtesy of Michael D. White.*

low ticket sales closed the premiere attraction on the ship. By the end of the 1970s, it was clear that something had to be done.

Jack Wrather signed a sixty-six-year lease with the City of Long Beach in 1980 to run all aspects of the ship, hotel, concessions and attractions. To try to bring more attention to the area, he made arrangements to bring Howard Hughes's *Spruce Goose* on long-term loan to Long Beach to be showcased next to the *Queen Mary*. Wrather had a giant geodesic dome built, and in 1983, the *Spruce Goose* was opened to the public and significantly raised attendance. Wrather passed away in 1984, but Wrather Port Properties continued to operate the ship until 1988. Jack Wrather owned the Disneyland Hotel, and the Disney Corporation had been trying to buy the Disneyland Hotel for years. In 1988, Disney Corporation saw its chance as the *Queen Mary* again began to lose money. Disney made an offer to assume the lease on the *Queen Mary*, and Wrather Port Properties jumped at the opportunity, even though it meant giving up the Disneyland Hotel as part of the deal.

The *Queen Mary* was never advertised as a Disney property. Disney only wanted the ship as a ploy to gain ownership of the Disneyland Hotel, and as

such, Disney treated the ship almost as an afterthought. The ship continued to lose money, so Disney came up with the idea to build a new amusement park on the adjacent land with the *Queen Mary* as the centerpiece. Port Disney, as it was to be called, would be a resort replete with all the Disney magic, as well as a new park that revolved around the world's oceans. Disney ran into trouble almost immediately. Because of the oil regulations, environmental concerns and traffic impact to the harbor, the resistance to the project was insurmountable. Disney decided to move on to other projects and gave up the lease to the ship in 1992. With Disney gone, the hotel could not function and closed on September 30, 1992, but the attractions stayed open for another two months. The *Spruce Goose* was sold to a museum in Oregon, and finally, in December 1992, the RMS *Queen Mary* shut its doors to everyone but the security guards.

On February 5, 1993, RMS Foundation signed a five-year lease with the City of Long Beach to operate and manage the property and ship. Later that month, the tourist attraction reopened, with the hotel opening the following May. The lease was extended to twenty years for RMS Foundation but only for the ship. Queens Port Development Inc. was given the lease for the surrounding property.

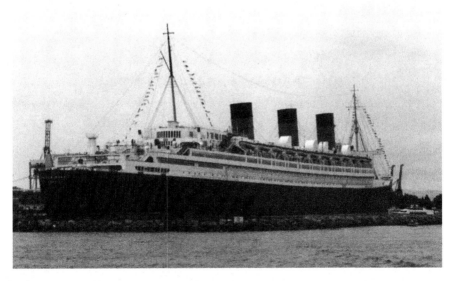

The *Queen Mary* after her conversion to an attraction. *Courtesy of Michael D. White.*

During the time the *Queen Mary* was closed, the only people on board were the security guards hired to protect the ship from vandals and those trying to sneak aboard. There are many tales from these guards of hearing noises that sounded as if parties were taking place on the ship, yet when these areas were approached, all sounds stopped. Others have told of hearing voices that would lead them all around the ship, letting the guard get close only to hear the voice again down a different passageway. Many guards would chase people around the decks only to discover that there was no one there. Quite a few of the security guards refused to enter the ship at all and would take watch only on the open decks.

Over the years since the *Queen Mary* reopened under the banner of RMS Foundation, the lessee has changed many times. In 2005, Queens Port Development filed for Chapter 11 protection over a rental dispute with the city. The current lessee has hired and fired so many management groups that consistency in operations is nonexistent. This has led to the ship losing money, as it has in the past, and leaves the future of this grand ship up in the air. The City of Long Beach seems oblivious to the plight, and the Historical Society of Long Beach won't even talk about the ship. Today she is still open to tourists and hotel guests, and we hope she will be for many generations to come, but for now, let us just say, "God save the *Queen*."

Chapter 6
THE HAUNTINGS

The RMS *Queen Mary* traveled the world's oceans for thirty-one years, and in that time, she sailed through storms thrown at her by Mother Nature and those devised by man. She weathered disasters and brought families together; she saw sorrow and joy, pain and pleasure and became a part of history itself. Death was a constant companion for the grand liner. She caused hundreds of fatalities when she struck the ill-fated HMS *Curacoa* and must take responsibility for the deaths of countless German and Italian prisoners of war while transporting them in horrendous conditions early in World War II. Many more deaths can be attributed to the ship from heat stroke during her trooping duties from Australia to North Africa. There are the famous fatalities many know about, such as the little girl who lost her life sliding down a stair rail, the officer who unwittingly drank poison and the poor lad who was caught in a watertight door. We know that other deaths from natural causes, suicide and accidents occurred, and there are still others that Cunard tried to hide for a more dark and sinister reason. All of this death, as well as the life, shared on the "Stateliest Ship Afloat" adds up to one thing: the most haunted ship in the world.

Almost from the moment the ship docked in Long Beach, stories of the paranormal began to surface. Those working to prepare her for dry dock would tell of seeing strange figures out of the corner of their eyes or would hear conversations where no one was present. Tools would disappear only to turn up somewhere else on the ship and in areas where their owner had never been. The reason for this sudden manifestation of spirits may never be known, but

Queen Mary at sunset. *Courtesy of Patrick Burns.*

some have speculated that the permanent residents of the *Queen Mary* knew that their days of sailing the open seas were over and were showing their displeasure; others theorize that the displeasure comes from the wanton destruction of the ship as it was being transformed from ocean liner to tourist attraction. Whatever the case may be, one thing is certain: the spirits aboard the *Queen Mary* are letting us know they are there, and they are there to stay.

Most people know of the more famous spirits that wander the corridors of the ship, but few know to what extent the ship is haunted. The late psychic Peter James said that there were at least six hundred spirits on board the *Queen Mary* and possibly more that we have yet to find. Over the years, many paranormal investigations have taken place on the ship, and the amount of evidence put forth is astronomical. The Lady in White has been seen and heard by many, and John Pedder has become a legend unto himself. John Henry and Sarah are well known, but perhaps the most beloved spirit on the ship is that of Jackie.

JACQUELINE TORIN

Peter James first found Jackie, a young girl of about five or six years of age, in 1991 while exploring the Royal Theatre with a film crew. He asked who she was, and she audibly replied, "Meet me in the other pool." James was confused because he didn't realize that the room he was in had been the

Could this be Jackie peeking back? *Courtesy of Priscilla Uriate.*

second-class pool during the ship's sailing days. Peter did as asked and met Jackie in the first-class pool, and what transpired there has now become part of paranormal legend. Peter conversed with Jackie for over ten minutes, and the whole conversation was caught on camera. This event helped launch Peter into the spotlight and spawned the hit television show *Sightings*.

Over the intervening years, many have tried to communicate with Jackie, and she has been very free with her time. She has a playful side and likes to have fun with people by playing peek-a-boo from the upstairs balcony. She will allow just a glimpse of herself and then quickly duck down behind the balcony only to appear in another part of the pool to repeat her game. Many times while people have walked through the pool, they have heard her plaintively calling for her mommy. It is believed that she remains on the ship looking for her mother, but so little is known about this child that one can only speculate. It is the authors' theory that the lack of any information for this sweet little girl is due to her possibly being part of the war bride cruises. What we do know is that she drowned in the second-class pool and now likes to play in the first-class pool. She does get around the ship, however, and has been seen in many other areas. The Lady in White has been known to sing to Jackie, and the girl known as Sarah has taken it upon herself to be Jackie's protector. The ghost known to us as Grumpy seems to have also taken an interest in this child, though why he has taken an interest we have yet to discover. In 2009, Planet Paranormal's own Bob Davis and Brian Clune caught Jackie in a very talkative mood while in the pool and recorded a seventeen-minute conversation with her, which included some very special interaction.

My First Encounter with Jackie and Other Phenomena As Told by Frank Beruecos

As a paranormal investigator, I have always been drawn to this beautiful ship, not just for the many spirits but also for the incredible Art Deco for which the *Queen Mary* is known. There are many paranormal hot spots throughout the ship, but as we all know, the first-class poolroom is the center of all the activity that goes on in the ship and is located in the heart of the ship. The corridor of dressing rooms located in the poolroom is rumored to harbor a vortex where the spirits enter and exit, and many psychics believe that a vortex is always located in the heart of a building or location.

I had conducted several investigations in the first-class poolroom over the years, but I came up empty with evidence. I finally had my first encounter with Jackie after several trips to the poolroom. On this one night, I was investigating the poolroom with a fellow investigator, and as we started an EVP session, most of our questions were directed to Jackie. As I called out to

Jackie, I asked her to appear. Finally, I heard an audible response that sounded like a very young little girl. Her response was simply, "No." I then asked if she could make the poolroom feel colder than it was, and again, I heard her audibly respond by saying, "No." Later, I would find that both her responses were captured on my digital voice recorder. As we continued the EVP session, a couple of the small lights that hang on the pillars of the poolroom started to flicker on and off, almost as if she was responding to our questions in that manner. This was strange because we had been in there for over an hour and the lights had not flickered until that moment. There were also different lights flickering, not the same ones each time. We were not able to clearly hear her again

Unidentified girl and male photographed in the museum area. *Courtesy of East Valley Paranormal.*

on this night. Jackie continues to be heard in the poolroom, but it is very sporadic. There is another reported phenomenon in the poolroom that is yet to be published and is rarely talked about. I have been witness to it on many occasions, as have other investigators who were with me. The only way to describe this phenomenon is that it is a fast-moving black mass or object that can be seen in one's peripheral vision. Most of the time, it has been seen moving very fast across the top mezzanine of the pool, and then it disappears. There is no explanation for it. I do believe that it was captured a few times on the poolroom ghost camera, but this phenomenon has yet to be explained.

SARAH

Sarah is another spirit that Peter James discovered while trying to communicate with Jackie. Very little is known about her, maybe even less than is known about Jackie. James has said that Sarah is six or eight years old but seems to have the ability to manifest herself to appear as a teenager. Sarah has taken it upon herself to be Jackie's protector and takes this task very seriously. When investigators are asking Jackie to talk to them, Sarah has been known to forcefully tell them no.

Peter James believes that Sarah possibly drowned in the pool in 1949, but there are no records that can be found to confirm this. There is another theory that she and Jackie were murdered by the ghost we call Grumpy; this again cannot be proven as there is no data to back the story up. Peter James once stated that Sarah can become agitated and aggressive and even claimed that Sarah became so mad at him once that she actually scratched him. Other people have also claimed that Sarah has become forceful with them to the point of scaring them out of the pool. We have encountered Sarah on many occasions, and she has always been pleasant, if aloof. Mr. James did say that after Sarah got to know him, her attitude changed, and she became much more pleasant to him. It would seem Sarah likes to get to know people before she can become comfortable with them. Sarah has also been known to wander about the ship but always stays close to Jackie, almost as if she has adopted the other child as a sister and companion for her in the afterlife.

GRUMPY

Bob Davis of Planet Paranormal first identified Grumpy. Bob gave him this moniker due to the spirit's habit of trying to scare people by growling at them. Also affectionately known as "Grumpy the Growling Ghost," it would seem as if his growls are done in a joking manner, but it is obvious that he wishes to be left alone. He seems to dwell in the storage area under the stairs in the first-class pool but does not stay solely there as he has been heard in the hallways leading away from the pool and in the Green Room area directly below the pool. No one is quite sure who this spirit is, but many believe that he is a former ship's captain. His behavior, however, does not fit in with the way a Cunard captain would carry himself. Another theory set forth by psychics is that he is a passenger who had killed a woman by

accident and then hid her body under the stairs in the pool. The woman's body was eventually found, and her murderer committed suicide to avoid prosecution. It is said that he is still on the ship because he is afraid of what awaits him on the other side as a consequence of his cruel act and refuses to pass on. One psychic has picked up on the name Roland in regard to this spirit, but this cannot be confirmed.

Bob has led friends and fellow investigators into the pool or boiler room on their first trips to these areas and is amused by their reactions when Grumpy says hello. He says, "They always have the same reaction—fear, shock and then laughter." Cigarette or cigar smoke is often smelled under the stairs in the pool, a sure sign that Grumpy is home.

William Eric Stark

Senior Second Officer Stark was getting off duty when the captain of the watch asked him to entertain a couple new crew officers, also getting off duty, and to try to make them feel welcome. Stark found the two new crew members and invited them to come by when they got the chance and then headed to his cabin. After arriving at his quarters, he summoned a steward and told him to fetch a bottle of gin. The steward knew that Stark was in a hurry, so he went to another cabin close by to see if he could find the gin and found a bottle on the first try. What the man didn't realize was that the officer who resided in this cabin had drunk all of the gin already and had filled the bottle with tetrahydrachloride, a strong cleaning solvent that is deadly if ingested. The steward took the bottle back to Stark, who poured himself a drink, mixed in some lime juice and enjoyed his leisure time before his guests arrived. When the two new officers arrived, they noticed that what Stark poured them wasn't gin. Realizing what the liquid was, they informed Stark, who just joked it off and went to find a bottle of actual gin.

The next day, Stark became violently ill and was taken to the medical ward, where he was treated. The two officers who were with him the night before informed the doctor what the senior second officer had consumed, but there was nothing that could be done. Over the next couple days, the doctors tried to make Stark as comfortable as possible, but the man still died in agony from the poison he had ingested.

Stark's spirit has been seen in and around the captain's quarters and roaming around the Promenade Deck. There have been reports of choking

Possible shadow figure behind pillar. *Courtesy of Donn Shy.*

sounds heard around the old hospital area and in the isolation ward. There are those who believe Stark may be the ghost known as Grumpy, which is why that spirit rarely talks but grunts and growls a lot. It appears obvious that Mr. Stark has remained on the *Queen Mary*, almost as if he is still trying to find his elusive bottle of gin.

JOHN PEDDER

John Pedder was only eighteen in 1966 when he worked on board the *Queen Mary* down in the engine room. For many young men in England, the chance to work for Cunard was a dream come true and meant a long and profitable career path had been found. Unfortunately for Mr. Pedder, a long, fulfilling career was not in the cards. Working in the sweltering heat of the boilers, generators and moving engine parts was hard and tiring work; the shifts would last hours; and the tedium of it could get overwhelming. To help with the dreary conditions, the crew members working in these areas would come up with ways to entertain themselves, and some of the ideas that came from the younger men were not only dangerous but also downright stupid. One of these was a game of chicken that would have disastrous consequences for young John Pedder.

Periodically, the captain of the ship would call for watertight door drills. When this occurred, an alarm would sound, and the crew would have only a brief time to get to stations or be caught in an area where they didn't belong. The doors were not slow, and the men began to "test their manhood" by running through the doors at the very last second to see who was the "nerviest." Unfortunately, one day as Mr. Pedder was trying to win the game, he lost his life. John was too slow and was crushed by the now infamous watertight door number 13.

John Pedder is known to haunt the area in shaft ally by door 13 and has become famous for his aloofness toward men and his forwardness toward women. John seems to prefer the company of ladies and likes to stroke their hair and tickle their ears, and some have even reported feeling his breath on their cheeks. Many people have reported seeing shadows dart down the hallway as they approach and then quickly disappear between the machinery as if hiding. Those walking near door 13 often report cries, strange audible moans and the sound of a man speaking in whispers.

There is another spirit that may be haunting the area around watertight door 13, but the details are sketchy. The tale goes that a John McKenzie was working on the ship sometime in 1942 and was so despised by his crewmates that he was physically held by the arms while straddling door 13 while it closed until he was crushed to death. His murder cannot be confirmed, but it is one of those stories that have been told on the ship long before she arrived in Long Beach. Whichever spirit is encountered down in the engine room of the *Queen Mary*, it obviously still has its hormones raging, as its love of the ladies can attest.

JACK AND TERRANCE

These are two of the lesser-known spirits, discovered by Rob and Anne Wlodarski, that are reported to inhabit the first-class pool area of the RMS *Queen Mary*. They appear to be soldiers who may have perished together during the ship's Gray Ghost era of World War II. As mentioned, the ship was designed for the cold north Atlantic, and many soldiers died from heat stroke during transport in the Indian Ocean and Mediterranean Sea. These two could be victims of this poor planning in accommodations. They always manifest together, which is one of the reasons it is believed they were friends and most likely died at the same time. Many people report hearing their names audibly as if they are trying to let us know that they are still here, and some believe that this is a cry for help. They are usually accompanied by intense heat, which could indicate they died as a result of fire or a heat-related illness, as stated above. They seem to be a bit playful, with guests reporting their clothes being tugged as a way of getting their attention. It is our hope that someday these two men will be identified and their history told to others in remembrance.

THE LADY IN WHITE

This beautiful young woman has been seen most often dancing to unheard music in the Queen's Salon. This room was the Main Lounge while the *Queen Mary* was still operating as an ocean liner and was where the rich and famous would gather to dance the night away to some of the best bands of the time. Her identity is not known, but she gets her moniker due to the lovely white evening gown she wears. There are many reports by guests on the ship that when they pass by the salon they can see her gliding across the floor gracefully dancing to a tune only she can hear. It is said that when one tries to approach her, she will vanish into thin air, and still others have said that she simply fades away.

The Queen's Salon is not the only place that the Lady in White has been spotted. The piano, which now sits in the starboard-side bar next to the hotel desk, is said to have originally been the piano that entertained guests in the Main Lounge. This could be one of the reasons that this gentle spirit has been seen often in and around the hotel lobby, as well as gracefully moving about on the staircases nearby. Other times, people have reported seeing her

A light anomaly caught near the first-class pool main entrance. *Courtesy of Donn Shy.*

in the isolation ward at the rear of the vessel and up front in the room that at one time was the Paranormal Research Center, directly aft of the Shrine of the Immortal Chaplains.

The Lady in White also seems to have adopted the little girl known as Jackie and, to a lesser extent, the spirit of Sarah as well. There have been times when people have been heading down the corridor leading to the first-class pool and have heard a young woman singing. This woman is believed to be the Lady in White. Her voice is always soft and soothing, and many times a child can be heard humming along with her. It is nice that, even in death, our souls can find one another and bring comfort when all else seems lost.

JOHN HENRY

John Henry was a welder/boiler room worker and is a fairly well-known spirit that resides in an area now known as the Green Room. This area was actually one of the ship's generator rooms but was made over into a dressing room for performers to change into costumes and relax before and after appearing on the now defunct Boiler Room Stage. There is some speculation about who John Henry is and what his job was while working aboard the *Queen Mary*. Some say that he was a boiler room engineer who was killed when a steam pipe burst and scalded him. The late psychic Peter James claims that John Henry was working on the construction of the *Queen Mary* and is one of the welders who were mysteriously found dead when work resumed on the ship following the Great Depression. Whichever story you subscribe to, John is another spirit that seems to like the ladies while all but shunning any man who enters his realm.

Many women who explore the Green Room area and the boiler room aft have reported having their hair stroked, their cheeks brushed by unseen hands and, on occasion, their rumps pinched. Men, on the other hand, have reported being shoved and tugged until they leave the area. Inside the Green Room itself, there is a square hole in the ceiling where people have seen glowing eyes, and others have reported seeing the full head and face of John Henry looking down on them.

Whatever job John Henry had while working on the *Queen Mary*, it would seem that he is stuck in this area of the ship, as he has not been reported anywhere else that we know of. One thing is certain: John has no trouble making himself known and his intentions clear to those who encounter him. He has never been known to hurt anyone, but he makes it clear that men are not that welcome in his domain, though the ladies are always encouraged to visit him.

"THE DUDE"

Sir Winston's restaurant is by far the premier eatery on the RMS *Queen Mary*. It sits above the Veranda Grill and was at one time crew quarters while the ship was in operation as a liner. It is also home to a spirit simply known as "the Dude." Another spirit discovered by Rob and Anne Wlodarski, whom this spirit is remains unknown, but since he is always seen in a top hat and

tails, it is believed that he was a man of distinction when alive and therefore appreciates the upscale ambiance and menu of Sir Winston's. He seems to prefer the bar area of the restaurant, and there are many reports of this gentleman approaching other guests from behind, clearing his throat until he is noticed and then simply vanishing. Other times he will turn and pass from view through the wall that leads to the men's restroom.

It is speculated that the Dude was a wealthy passenger who, like many other first-class travelers, liked to frequent the Veranda Grill. The Veranda Grill was where the rich and famous would gather for an intimate dinner and then afterward would dance the night away to some of the finest bands of the day. Since the Veranda Grill is now a for-rent banquet room, it is believed that this spirit has found Sir Winston's an easy match for the days when he traveled. He has been spotted standing or sitting alone, watching the guests with a slight smile on his face and not a strand of his slicked-back hair out of place. It is as though he is admiring the crowd and takes pleasure in their gaiety. Whenever anyone approaches this gentleman specter, he simply vanishes before anyone can converse with him. As with most of the spirits that remain on board the *Queen Mary*, this apparition has never threatened or menaced anyone but seems content to watch and admire those still living who venture into the restaurant that he now calls home.

THE WOMAN IN THE BATHING SUIT

This is the spirit of a pretty young woman in her late twenties to early thirties who wears a bathing suit in a style consistent with that of the late 1930s. Because of the special effects incorporated in the Ghosts and Legends tour that passes through the pool area, many believe that this spirit does not actually exist. There have been many credible reports about this woman—so many, in fact, that it seems unreasonable to deny her existence. She has been seen on both the upper and lower levels of the first-class pool, and people have noticed that she often leaves wet footprints behind before vanishing from sight. There have been other times when people have seen her walk from the pool and disappear into the change room corridor, as if retiring to change out of her suit.

The Ghosts and Legends tour has ceased manufacturing wet footprints due to the deteriorating condition of the lower level of the pool, so now if you happen to see them, you can be assured that they are actually those of

the spirit and not special effects designed to fool tour guests. Hopefully this young woman will now get the attention she seems to be looking for from those who are ready to believe.

DANIEL

Daniel is perhaps five or six years old and is often referred to as "the Blue Boy." This name comes from the fact that he is always seen wearing what appears to be Edwardian-style clothing in a distinctive blue color. This lad is most often seen wandering the Promenade Deck and around the staircase in the Piccadilly Square shopping area of the ship. It would seem from the EVPs that have been captured that he is looking for his parents. Since Edwardian-style clothing went out of style around 1914, it could be assumed that this child may have been from a poor immigrant family, unable to afford up-to-date clothing, traveling to the

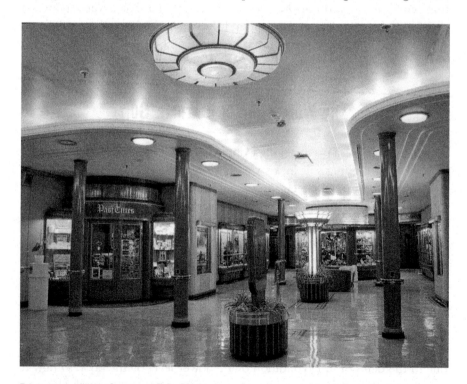

Promenade shops. *Courtesy of Dave Twolen.*

United States early in the sailing career of the *Queen Mary*. This child has also been spotted in the Observation Bar and in many other areas of the upper levels of the ship. It is hoped that someday we will get more information about this little boy and hopefully reunite him with his family.

DANA AND PENNY

According to the late Peter James, two sisters were murdered by their father in room B-474 sometime in 1959. The father was distraught for an unknown reason and murdered his wife and two daughters and then killed himself. Dana, four; Penny, two; and their mother were found in bed, strangled by a ligature, and the father was found in the bathroom, a victim of a self-inflicted gunshot wound. The girls have been seen and heard in the room on B deck and in the surrounding corridors, oftentimes playing with each other. Dana has been spotted in the cargo hold area and has been heard playing in and around the Archives section in the forward areas of the ship. Both girls have been heard calling out to their mother, so it is assumed that she has passed on while her children have remained behind. Odd as it may seem, these two little girls have been reported in the Green Room area of the ship and have been caught playing in the boiler rooms as well. Other favorite haunts of theirs are the former second-class pool area and the Royal Theater.

"FEDORA DUDE"

This is a disturbing figure first spotted by Bob Davis and his daughter, Katrina. He gets his name from the yellowish tan zoot suit he wears and his bright yellow fedora hat. He is an extremely tall man with rotting teeth and hollow, yellow eyes. "Fedora Dude" is often seen around the lobby area of the hotel and likes to smirk at people as he passes by, almost as if he is hiding a secret about those he is looking at. He usually passes close and then turns down the corridor out of view. If you try to follow him, you will discover that by the time you look down the hallway, the fedora-wearing specter has already gone so far down the ship that it would be impossible for any living being to accomplish the same feat.

He will turn back, smile and then simply fade from view. Who or what this spirit may be is a matter of speculation, but everyone who has come across him has felt unease after their encounter. He is not relegated to the hotel lobby and has been seen all over the ship in the public areas at all times of the day and night.

JEREMY

Jeremy is a young spirit first reported by the late Peter James. This lad was seen by James playing with the spirit of little Jackie in the first-class pool. Many have tried to find out the identity of this boy, but to this day, it cannot be verified. There have been reports of tour groups having heard him during the Ghosts and Legends tour, as well as security and the old fire-

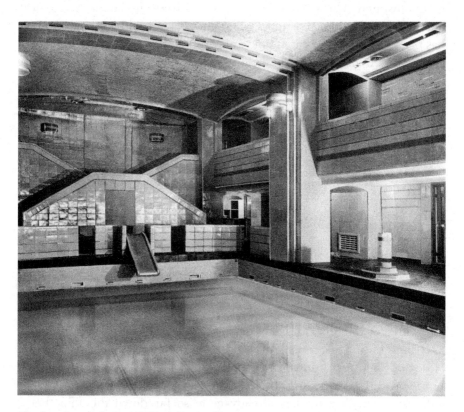

The first-class pool, circa 1936. *Authors' archive.*

watch crewman hearing him while patrolling the pool area. Whoever this boy is, it is heartening to know that he has found a friend in the afterlife to share his time with.

DAVID AND SARAH

This couple, first discovered by Rob and Anne Wlodarski, has been known to frequent Sir Winston's restaurant and the first-class pool. It would seem that they are searching for their lost children, but no one has been able to identify who those children might be. They are always seen moving about the ship together and will answer direct questions if those queries are asked using their names. Due to the fact that there are many spirits of children on board the *Queen Mary*, one can assume that if any of those young ones had been the children of David and Sarah, they would have been united and hopefully passed on by this time. Some have put forth the theory that David and Sarah could be the mother and father of Dana and Penny and that the girls have been hiding from their father. This seems unlikely, however, because Dana and Penny's mother was a victim of her husband, and the girls would probably not shy away from their mother if these spirits were related in this way. It is hoped that this family will be reunited and spend the afterlife together.

CARRIE

Carrie is a little girl who has been heard playing in the boiler room area of the ship and in the first-class pool as well. Carrie seems to be very shy and is heard very rarely. Because of this, no other information about her can be given at this time.

WINSTON CHURCHILL

Winston Churchill was the prime minister of England during World War II and used the *Queen Mary* almost exclusively to travel to his meetings throughout the war. He would always travel under the code name "Colonel Warden" and

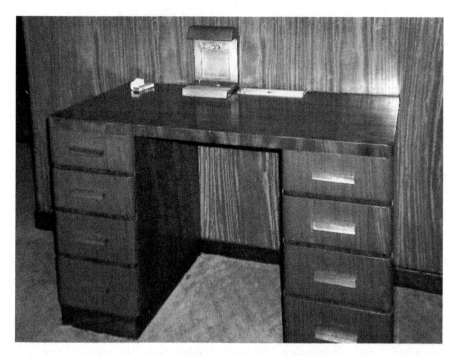

Winston Churchill's desk in the Churchill Suite. *Courtesy of Dave Twolen.*

would usually bring along a large entourage of clerks and assistants to help facilitate his work. He would usually work from his suite on M deck, but Cunard also set up an office for him on the Promenade Deck. Churchill even signed the D-Day orders while sailing aboard the liner at the desk that still remains in the Churchill Suite to this day. Winston Churchill was a strong man in a terrible time for our world but in private would always worry whether he was doing the right thing in sending men off to die, and this strong emotion may be the reason that he remains on board the *Queen Mary* even now.

The smell of cigar smoke has been noticed quite often emanating from the suite that bears his name, and guests have even reported hearing the sound of pacing and worried mumbling coming from the room when there were no guests booked in the suite. Could this be Winston still fretting over signing the orders that would send hundreds of his countrymen into battle and to their possible deaths? This same cigar smoke has also been noticed in and around what at one time was his office in the shopping area known as Piccadilly Circus, as well as in the restaurant that bears his name at the rear of the ship. It would seem that Colonel Warden is still enjoying his time on the pride of Cunard and making sure that Sir Winston's is living up to his standard of excellence.

CAPTAIN JOHN TREASURE JONES

J. Treasure Jones was born to a life at sea, having joined the Gould Steamship Company just before the age of sixteen. After his four-year apprenticeship, he went on to serve on tramp steamers until he signed on to work with the White Star line in 1929. White Star, in turn, sent him to do twelve months of training in the Royal Navy Reserves, which he had already joined in 1925 and where he had spent six months on the famed HMS *Hood*. When his tour was finished, White Star laid him off due to the Great Depression, and Jones moved around to different companies, including Cunard White Star, where he rose to senior third officer on the RMS *Britannic*. He worked on the *Britannic* until the start of World War II, when he became an accomplished Royal Navy commander.

In 1947, he rejoined Cunard, serving on various liners, including the *Queen Elizabeth*. In 1954, he was promoted to staff captain aboard the RMS *Queen Mary* until he was given his own command aboard the RMS *Media*. Then in 1962, Jones became captain of the fabled RMS *Mauretania* and would be her commander until he delivered her to the ship-breaking yard in November 1965. John Treasure Jones would also oversee his next charge on her last great cruise, for in December 1965, he became master of the greatest ship

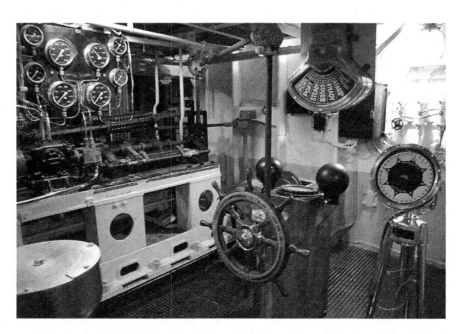

Auxiliary control room. *Courtesy Dave Twolen.*

afloat, the queen of queens, the RMS *Queen Mary* herself. For two years, Jones would guide the pride of England along the North Atlantic route until she was sold to the City of Long Beach. Then from October 31 to December 9, 1967, he would lead the grand lady on her final voyage to her new home; he would hand over the reins of the greatest liner to ever sail the oceans to the upstart California city on December 11, 1967. Jones would then fade into memory, retiring in August 1968 at the age of sixty-three. Jones had spent forty-seven years in his career—forty-three of them continuously—at sea. Captain John Treasure Jones passed away peacefully on May 12, 1993, just three months shy of his eighty-eighth birthday. However, it would seem that Captain Jones was not ready to give up his charge and remains the loyal master of his greatest ship, for today he can still be found on the RMS *Queen Mary*.

J. Treasure Jones has been seen and heard all over the ship, but the bridge seems to be a favorite haunt of his, as one can imagine. There have been reports of him standing in the wheelhouse staring out the front windows, as if looking to the horizon while guiding the giant ship through the waves. Other times he has been spotted on the port or starboard flying bridge, looking fore and aft in the way he would have while docking the ship. Each time, when the witness looked away and then back to where the captain had been seen, he would be gone. The remnants of the captain's quarters are just below the bridge, and Jones has been seen resting in the small living room and office area, as well as heard softly humming in the bedroom. Captain Jones loved his cigars, and the smell of smoke has been reported near his cabin quite often, even though smoking is strictly forbidden on board the *Queen Mary* today.

There are some who believe that Captain Jones is also the spirit we know as Grumpy and point to the smell of cigarette or cigar smoke that sometimes accompanies Grumpy as an indicator that it is indeed Jones. As was stated earlier in this narrative, Grumpy the Growling Ghost does not carry himself as a professional sea captain, and if nothing else is known about Captain John Treasure Jones, it is that he was a consummate professional, a true gentleman and, above all, the *Queen Mary*'s penultimate ambassador. Jones has been seen in and around the pool area, however, always in uniform—in fact, Captain Jones has never been seen out of uniform. Whether walking along the Promenade Deck, manning the wheelhouse or scanning the hull from the flying bridge, Captain Jones is always spit and polished in his Cunard naval uniform.

There is one area of the ship that has been known to be a hot spot for hearing Captain Jones either audibly speaking or catching him in EVP:

the propeller box. It is unknown why Jones frequents this area, but some speculate that he may be concerned about the great hole that is now cut out of the ship's hull to allow visitors the opportunity to view the last of the *Queen Mary*'s four giant propellers. The captain has been seen and heard at the same time by many guests, but each time he has been approached, he simply fades from view or passes through a bulkhead and disappears.

Even though Captain Jones died far across the Atlantic Ocean at Chandlers Ford, just outside of Southampton, England, his dedication to duty may have drawn him back to the greatest liner ever built. Knowing that his ship was still afloat in the United States and still in need of experienced guidance and care may be the reason that he tends to her needs even today. As a seafaring man, what better way to spend your afterlife than forever as the master of the RMS *Queen Mary*?

Going Up?
As Told by Lee Frankel

I was at the *Queen Mary* for a meeting with my company in January 2013. I checked into the hotel, was given my room key and then headed to the elevator. When I got there, the captain of the boat, in his white uniform and hat, was already waiting for the car to arrive, and we both stood there until the doors opened. When the elevator doors opened, I stepped inside, and the captain followed. I asked him if I could press a floor button for him, and he just stood there staring at me without replying. When we arrived at my floor, I got out, wished him a nice day and proceeded to my room.

Later that night, a group of co-workers and I were talking to one of the women at the front desk who was telling us about the different tours that the ship offered, including the ghost tour. I laughed and said that the captain should lead the tour because he was kind of creepy looking and not very responsive. She then went on to tell us that the ship had no captain because it was designated a building and that they had no one working that day who would have been dressed as such. She went on to tell us that several of the ship's past captains do haunt the ship, however. I told her, "No, that's not possible," at which point one of her co-workers said, "Sir, there is no [living] captain."

SHADOW PEOPLE

Shadow people have been reported in all areas of the ship at all hours of the day and night. There are many theories about what shadow people are. Some people believe they could be inter-dimensional beings slipping between our dimension and theirs. Others think that they are simply another form of spirit or ghost, while still others believe they are "men in black," somehow not fully cloaked as they enter into our domain from theirs. Then, of course, there are those who believe that these shadow figures are demonic entities or perhaps demons themselves. Whatever these strange beings may be, one thing that is certain is that once you see a shadow person, you will be hard pressed to forget, even if you want to.

A possible shadow person on portside B deck, aft. *Courtesy of Planet Paranormal.*

These entities appear in many forms: some are tall and thin, others short and fat and still others defy description. They appear to be clothed in any manner of dress, with some wearing trench coats and hats and others appearing to wear business attire; there are some that have a more sinister look and appear cloaked and hooded. Many people report them as having an almost smoky appearance, while others claim they seem to have the look of oil on water and still others report them as having a shimmering aura about them.

Many people have reported walking down one of the ship's long bowed hallways and seeing one of the figures farther along just standing and staring their way. Sometimes these entities simply vanish from view, and other times they appear to walk into the walls, but each time one has been witnessed, the viewer is left with a feeling of foreboding that is hard to shake off. There are other times that the shadow figure has been seen walking along one of the upper decks and then will quickly turn into one of the doors leading to the ship's interior. When the witness looks where the figure turned, there is no longer anyone there.

We may never know what these specters truly are, but it is certain that they exist and visit the *Queen Mary* often. It may be that they are drawn to the ship's history or perhaps the number of deaths that have occurred on the ship, but either way, once you have witnessed one of these possible dark entities, you will never forget what you have seen.

BALLS OF LIGHT

These are different from what are usually referred to as orbs. Orbs show up on digital cameras and, more often than not, are attributed to moisture, dust, bugs or other similar small particles, as well as lens flare or lens refraction. Orbs can also be caused by the various lens coatings used by the manufacturer, which can also cause the orbs to appear in different colors, depending on what coating was used. The balls of light we are talking about here are visible to the unaided eye and range in size from that of a grape all the way up to the size of a softball and possibly even larger. They are often blue in color but have also been reported in colors across the whole spectrum. These balls have been witnessed in many areas of the ship and have been seen by the authors on three separate occasions. While investigating the Green Room area of the boiler rooms, these balls were baseball-sized and bright

blue in color. They traveled in a straight line but had a slight up-and-down wobble to them. There are many great photographs of these anomalies, and you can clearly see that they have a definition or depth to them. They don't look flattened like dust orbs but have a very solid appearance. They seem to produce their own light and can be seen in total darkness just cruising along before your eyes. It has been speculated that they could be a form of ball lightning or possibly some form of spirit activity.

There is a phenomenon that we have seen that takes place deep in the forward cargo hold. This manifests as a form of light that appears almost as if it were alive. There have been times that we have been down in this area and have witnessed lights that have zoomed around the cargo hold, while at other times, they have appeared almost star-like up by the ceiling. The source of these lights is unknown. Some people believe that these lights are the spirits of the crew members of the HMS *Curacoa*, and others believe that they could be the spirits of German and Italian prisoners of war who perished in the cargo hold.

Chapter 7
THE HOT SPOTS

There is no doubt that the RMS *Queen Mary* is the most haunted ship afloat and perhaps even one of the most haunted places on planet Earth. Over the years, an argument has arisen among paranormal investigators, employees of the ship, guests and the Internet public at large over which deck, room or location on board is the most haunted section of the old liner. Many people believe that it is B deck; this deck has seen its share of murders and fatal accidents, and it houses the isolation ward in its aft section, as well as the morgue during World War II. It is easy to understand why there are those who would think that with all these factors, it could be the most haunted deck. There are others who believe that the forward cargo hold is the place of the most activity, perhaps due to its proximity to where the *Queen Mary* sliced its escort ship in half during World War II, with the loss of over three hundred men, and the fact that many prisoners of war died here in transit on their way to the United States during that same war. This makes the hold a prime candidate for the ship's most haunted area.

Among paranormal investigators, you will find that almost all, if asked where they believe the spirits make themselves known, will most often tell you the first-class pool. This is because most investigators spend the majority of their time in the pool trying to get little Jackie to speak to them and visit the other hot spots as a diversion of sorts. That is not to say they don't take their investigations seriously in the other locations; it's just that Jackie has become the prize, shall we say, that is most coveted. Still, there are other investigators who will tell you that in the Engine Room, Green Room,

isolation ward and any other number of places, they have captured EVPs or audibles, seen shadows or mists or have just had that creepy feeling one can get when spirits are about. Peter James has said that there are at least six hundred spirits aboard the *Queen Mary*. With that many entities, it is hard to believe that they would all congregate into only a few areas aboard this marvelous relic of the past. It is our belief that the permanent guests and crew of the liner are still going about their business as if they were still alive and most likely move from place to place.

Planet Paranormal team members have had the great privilege and honor to be part of one of the only teams to have unfettered access to the ship, and in that time, we have found that there is not just one place that you can call the most haunted area. It changes from year to year, week to week and day to day. We were thrilled when Jackie chose to speak to us for over seventeen minutes while in the poolroom but then found her speaking to us at a later date clear across the ship. We have heard Grumpy in several areas, and Captain Jones, it seems, still inspects every inch of his proud vessel. When we are asked what is the most haunted area of the *Queen Mary*, we simply say, "The ship itself."

Even though there is no single place that can be called the most haunted place on the ship, there are those areas that have become famous for the amount of activity recorded and for the spirits that dwell there. Some of these locations have earned their reputation, and others have not. Either way, they have now become as much a part of the *Queen Mary*'s history as her time at sea and shall remain so as long as the ship is afloat. Always keep in mind, however, that the ship can and will surprise you when you least expect it. You may be sitting down to dinner, walking down the hallway to your room or simply turning in for the evening when you find that you are not alone but rather in the presence of one of her permanent residents.

Room B-340

This room all the way forward on the port side of B deck has become one of the most famous places on board the *Queen Mary*. It has been featured in numerous books as perhaps the most haunted spot on the ship. It has been featured on many historical television programs dealing with hauntings and was even turned into a controversial segment on the hit show *Ghost Hunters*.

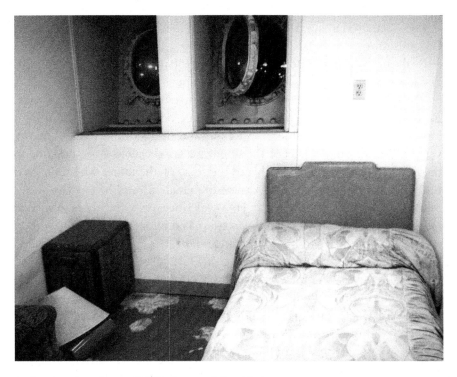

An interior view of room B-340. *Courtesy of Dave Twolen.*

Its legend has taken on a life of its own, and anyone who knows about the *Queen Mary* knows about room B-340.

The story goes that a family was brutally murdered in this room and their restless spirits are so active that they make the room unusable as a hotel room. The family was killed late in the evening, and there are tales of ghostly moans coming out of thin air in the middle of the night, doors opening and closing of their own accord and water taps in the bathroom turning on and off at will. One of the most enduring tales is about the covers on the bed moving after the bed is made and being pulled down to uncover wary guests while they sleep. This last tale was the catalyst for the controversy involving the crew members of the show *Ghost Hunters* and an employee of the ship, all of whom accused the other of fraud when the show caught what it thought was the covers moving.

There is a slight problem with all of these ghostly happenings in this horribly active hotel room, however: none of it ever happened. Room B-340 has never been a hotel room while the ship has been in the City of Long Beach, has never had anyone murdered inside its doors and had

always been used as storage until Disney decided to create the Ghosts and Legends tour.

By the time the hotel opened in 1972, only 150 rooms had been completed, and it was later found that the demand was not as high as expected, so many of the rooms slated for conversion were left empty and used for storage. Room B-340 was one of these. Once Disney began operating the ship, it looked for ways to draw more visitors in and decided that playing on the very real paranormal aspect of the ship was a good way to draw attention to the liner and her past. Having heard the story of the father who murdered his family back in 1959, Disney decided to create a room where the ghosts related to this tale would reappear. However, since the room where the actual murders took place, B-474, had been converted into a usable guest room, it was decided to use room B-340 instead and create a whole new story line to frighten its guests.

Over the years, the tales of B-340 have taken on a life of their own, and as will happen, people began to imagine all sorts of things taking place. With each retelling, the tale has grown until the truth about the allegedly haunted room has been lost in time. That is not to say that there is no activity in the room, as every room on the *Queen Mary* can and will have spirit activity; it is just that you will find no more and no less there than in any other guest room.

Room B-474

This room at the aft end of B deck is where Disney came up with the idea to transform room B-340 into an attraction billed as the most haunted room on the ship. This room, however, just may be the real thing. Guests have told many tales of ghostly occurrences happening in this cabin almost from the first day the hotel has been open.

Sometime in 1959, on a voyage from Southampton to New York, a young couple occupied the cabin with their two young daughters. Not much is known about them, but a tragic event occurred on the cruise that would shake the crew of the *Queen Mary* and leave Cunard scrambling to keep it as quiet as possible. Late one night, the father, in what we assume was a fit of depression, strangled his wife and two daughters while they were asleep in bed and then went into the bathroom and shot himself in the head. The sound of the gunshot brought the master-at-arms, who found the grisly scene

A possible apparition heads to the Green Room. *Courtesy of Ron Yacovetti.*

when he entered the cabin. The incident was kept quiet, and the bodies were stored in the isolation ward until the ship docked in New York and the family could be notified.

Room Service
As Told by Joe Hawley

My most memorable experience happened back in mid-2011, when Gail and I decided to stay on board the *Queen Mary* in room B-476. The moment I walked into the room, I began recording and almost immediately caught an EVP of a man and a woman arguing. It sounded as if it was coming from the room next door, B-474. There was no one in that room and no one walking down the hallway because we would have heard him or her, and we heard nothing at the time the recording was taken. We continued to conduct EVP sessions the rest of the evening with a few more responses, but once my wife went to bed, things really got crazy. I was sitting with

my back up against the closet door and kept feeling cold breezes, and the floor felt as if someone was running around the room while at the same time I had the feeling as if someone was standing over me, just watching what I was doing.

We went back a few weeks later and again stayed in room B-476 with another family member. I was telling her what happened on my previous visit and what I had since found out about room B-474. After I finished my story, she walked over to the closet and opened the door as if to set free whatever it was that might have been in there. Within seconds of the door opening, I felt a dark energy come into the room and stand right next to me. I caught a flash image of a male standing there, his arms crossed in a "what the hell do you think you're doing?" stance. The whole time the closet was open all I could think or feel was anger, and I saw only red. I told my companion to close the door quickly, and slowly the feeling of rage subsided, so I told her it was time to take a break.

We went back to the ship a few more times before I found out from a Facebook friend about what had supposedly occurred in room B-474 with the father who murdered his wife and kids and then killed himself as well. After I told her about what happened [to me] on the *Queen Mary*, she informed me that she has had similar experiences and mentioned a spirit by the name of Ann. Cornelia was going to be on the ship, so I made arrangements to stay the night in room B-474, and she was going to stop in so we could investigate together.

The next time we stayed in the room and waited for Cornelia to arrive, we conducted an EVP session, but at first there were no responses. However, as time went on, I began to feel dizzy and felt a hand close around my neck and begin choking me. My wife, seeing what was happening, quickly pulled out her holy water and proceeded to say, "You are not allowed to hurt anyone. You are not stronger than God," while splashing the holy water on me. I went into what I can only describe as a trance, and again, extreme anger and rage was overtaking me. I was told I began laughing in what was the creepiest laughter anyone had ever heard and didn't sound like me at all. I wanted to lash out at someone—anyone—and it didn't matter whom.

After I came out of the strange trance, almost immediately we began hearing whispers all around, and strange knocking began to come from the walls. The loud knocks sounded as if someone was hammering his fists on the walls, and it sounded as if it were coming from room B-476. We checked at the front desk but were told that the other room was empty, so the knocking could not be coming from there.

We left the front desk and headed to the Observation Bar to meet Cornelia there instead of at our room, but as we were walking, my mom froze dead in her tracks and told us that someone was pushing her in the back, and she was afraid to turn around. We told her that there was no one there and then quickly made our way to the front of the ship and the bar.

ISOLATION WARD

The isolation ward is another area on B deck that has been classified as a hot spot for paranormal activity. This location is at the extreme aft end of the ship and is accessible from either a locked door at the end of the hallway (for which you will need to be accompanied by a ship employee) on B deck or from the fantail. The isolation ward is now a stop on the self-guided tour.

While the ship was in service, this area was part hospital and part disease control room. In the *Queen Mary*'s early career, little was known about how infections or diseases worked or spread or how best to stem the transference of the various maladies that could find their way onto the ship during a sailing. Whenever a passenger was found to be carrying a contagious disease, he or she was placed here to isolate him or her from the rest of the passengers and crew. Stowaways were also often kept here, as well as anyone found to be suffering from mental disorders and deemed dangerous. This area was also the main medical ward for the second- and third-class passengers (with first-class passengers and crew members having their own separate medical ward), as well as where prisoners of war were taken when they became ill in transit. With all of the suffering that took place in this one small area, it would be hard to believe that it would not be haunted.

Reports over the years include guests seeing spectral doctors moving about the different rooms of the ward, what appear to be men and women lying down in the bunks that are now behind a glass partition and nurses tending to unseen spectral patients. Others believe that a nurse may have been one of the unfortunate few who lost their lives in the ward and is now drawn back to the place where she perished. There have been tales of people hearing voices speaking in both German and Italian, which could be some of the prisoners who have not yet been able to pass on from their mortal suffering.

Just beyond the isolation ward was the location of one of the morgues that had been set up during World War II. The area is off limits during most times of the year, but it becomes part of one of the mazes during the *Queen*

Could this anomaly to the left of the photograph be a visitor from beyond? *Courtesy of Gerald and Heather Reynolds.*

Mary's "Dark Harbor" event in the Halloween season. Many people claim that they have seen real spirits mixed in with the actors hired to scare people during the show, and even some of the actors themselves have either refused to work in this area or have flat-out quit because of their experiences while working in this section of the ship.

When you visit the *Queen Mary* and are enjoying this part of the walking tour, keep in mind that the doctor or nurse you see may not be exactly who or what you think they are. It is quite likely that you may be looking at one of those dedicated medical professionals who could not in good conscience leave their charges until they knew they were well and recovered. Other activity includes hearing the suffering moans of the sick as well as spectral conversations taking place between, it is assumed, unseen doctors discussing their patients. The Lady in White has also been spotted in this area quite often. It is speculated that this kind soul comes to visit and cheer those that are still present here, as a ghostly candy striper.

ROYAL THEATER

This area in the stern of the ship, directly across the hall from the propeller box, is said to have been the old second-class pool. We have found evidence, however, that the pool was a bit more forward than this site, but in either case, we do know that it seems to have some permanent theatergoers. Long Beach State University and local acting groups now use the Royal Theater for their productions.

Peter James first discovered the little ghost child Jackie here during one of his many filmed investigations aboard the *Queen Mary*, and that meeting helped launch him to fame as one of the foremost psychics of our day. It led to him having a recurring role on the hit show *Sightings* and allowed him to expand his aid to law enforcement agencies across the country.

Some of the reports that come from this area include the sound of music playing and shadows being seen both moving about and sitting in the audience as if watching a show in progress. Jackie has been heard often speaking or just calling out a quick greeting to those who enter. There are also many tales of at least one spectral cat that makes itself known, but others claim there are more of the furry spirits than that. Captain Jones has been heard in the area just outside the theater in front of the propeller box itself. The Lady in White has also been heard and seen here, and people claim to have heard Grumpy growling now and then.

It seems that the Royal Theater is a gathering spot for entertainment among the ship's resident spirits, so if you happen to be in the area on your tour, keep an eye out for the well-dressed patrons and the crew members that may be there to see a special show that's just for them.

ENGINE ROOM/WATERTIGHT DOOR 13

Watertight door 13 is in the aft end of the engine room exhibit on the starboard side of the ship and is considered a very haunted location. In this area, there have been at least two deaths that we know of caused by this seemingly unassuming hatch. The watertight doors were designed to be activated from the bridge when water was detected entering the ship to keep the sea from spilling into the other sections and sinking the liner. The bridge, in an effort to make sure the doors worked properly and to keep the crews on their toes, would have watertight door drills a few times each cruise.

The crew members would actually play a game of chicken with the door as it closed, and unfortunately young John Pedder was not fast enough and was crushed and killed while trying to pass through the portal. Another crewman by the name of John McKenzie may have been murdered at this site as well. Apparently, Mr. McKenzie was so disliked by his fellow crewmates that he was held by the arms between the moving door as it closed and was found still caught between the hatch and the bulkhead when an officer discovered his lifeless body.

John Pedder was only eighteen years old when he died, and most of us know what the hormones of a teenage male can be like. It should come as no surprise that Mr. Pedder likes the company of women. John has no shyness when it comes to letting the women who visit his area know that he is interested in them. There have been many reports over the years of Pedder physically touching girls who linger in his area of the ship, with some of the attention being a bit too forward. Pinches on the rump are rare but have happened on occasion, as well as light slaps on the derrière. Most of the interest Pedder shows is a bit milder and manifests as light brushing of fingertips across one's cheek, the stroking of hair and light, breathy whisperings in the ear. He rarely will pay any attention to male guests, however, and those times that a gentleman has caught sight or sound of him are few and far between.

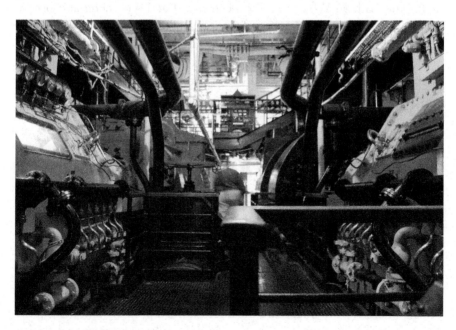

The aft engine room. *Courtesy of Dave Twolen.*

Some other reports that have come from this location of the ship include the sound of chains or gears moving about, knocking in one part of the engine room and then moving to another spot when approached, balls of light slowly moving across walls and walkways and even shadows seen moving about the machinery. There is a tale told by more than one visitor of seeing a man riding up the elevator who appears to be wearing an engineer's uniform from the time the ship was in sailing operation. There are no actors hired to portray one of these crewmen, so the guests just may be looking at John Pedder or Mr. McKenzie. There have also been people who have come out from the engine room walking tour looking very frightened. When asked, they all tell the same tale of having the feeling of being followed and hearing footsteps behind them but then finding no one there when they turn around to look. Each time they start to walk away, the feeling and noises return until they are out of the engine room and away from door 13.

The engine room tour is fascinating in that it gives you a glimpse of what it must have been like to work in the heart of the ship, confined in the oppressively hot, cramped environment well below the water line. If you decide to see for yourself, keep an eye out for John Pedder or Mr. McKenzie; who knows, they may just take a liking to you, or they may escort you out of their domain.

The infamous watertight door number 13. *Courtesy of Dave Twolen.*

Something Strange in the Engine Room
As Told by Teri Nixon

It all started back in 2009, when I joined the paranormal meetup group 3am Paranormal. In fact, our first meetup was on the *Queen Mary*, and it was then that I was introduced to the first-class pool area. I was amazed at the beauty of the Art Deco style but was saddened at the lack of care given to the upkeep of the pool and the ship in general. We had visited the ship a few times afterward, and on one of those trips, my husband, Michael Hawe, and myself, along with Lisa Arnold, ran into our friends Gian and Shirley Temperilli and their daughter Sophia. We had met them once or twice before while investigating the dressing room and pool area and liked hanging out with them whenever we ran into them on the ship. This particular time we decided, however, to go to the engine room.

We made our way to the engine room by going through the exhibit hall, which at this time was being cleaned up after a party, and headed back to the black curtains that hid the door we needed to go through to get to the back of the ship and door 13. As we passed through the curtains, however, we noticed a guy wearing black pants and a white shirt rummaging through some boxes, but we proceeded past him and through the door leading to the engine room. Gian and his family entered first, followed by Lisa, myself and another couple who had joined us as we made our way to the back of the ship and then my husband, who was bringing up the rear.

We were moving down the metal walkway headed for our destination when we rounded a corner and came to the bottom of the escalator near door 13. That was when we noticed somebody who was not part of our little group. He had not come completely around the corner but was just standing there facing us with a blank look about him, not making eye contact with us. He was wearing black pants and a white dress shirt like the man we saw by the door, but this person was also wearing a black hoodie. I asked Gian, "Who is that? Do you know him?" Gian told me that he wasn't with us, and my husband, Michael, told us that this guy had been right behind him the whole time we were making our way to door 13, and it felt as if the guy had been invading his personal space, way too close to him. This is when the strange man just backed up around the corner and away from our view. We just stood there, all of us shaking our heads and wondering where this guy had come from. He then popped out from around the corner again, stood there a minute and ducked back out of sight again. He emerged once again, but this time as he backed up around the corner, Shirley, Lisa and I went

after him. We turned the corner the guy had ducked behind, ready to confront him, but found that in the few seconds it had taken us to round the corner, he had vanished. If he had run down the metal walkway, we all would have heard him, and if he had tried to jump over the railing to hide among the machinery, we would have heard that, too. We also knew that if he had made it to the squeaky wooden door that led back to the exhibit hall, we would have heard it open. The three of us started running back to the entrance to the engine room and looked everywhere, even beyond the black curtains of the hall, but could find him nowhere. We got back to where the others waited for us and told them that we couldn't find him and that he had just disappeared. We discussed the situation and the fact that he never made eye contact with any of us and that he had no expression on his face whatsoever. I would say that this is one of my best experiences because it wasn't just me it happened to; there were eight of us there, and we all witnessed it.

Propeller Box/Life Aboard Museum

When Cunard sold the *Queen Mary* to the City of Long Beach, the company wanted to make sure that she could never sail the oceans of the world again. To this end, it placed this stipulation in the contract of sale. Long Beach, always a forward-thinking city, decided that one of the ways to fulfill the contract and to add a selling point to the viewing public would be showing off one of the ship's massive propellers. Three props were removed, but the fourth was encased in a watertight box big enough for a walkway that would allow guests to stroll around above the water line and see the propeller. To create this walkway, however, two giant holes would have to be cut out of the hull on either side of the box, thus making the ship completely unseaworthy.

Over the years, guests walking through and marveling at the huge brass propeller have reported hearing the sound of a disembodied male voice echoing in the box in a worried tone. Many believe that this person is a former captain of the ship, as they have also heard him issuing what sounded like orders to other unseen crewmen. There are those who think this captain is none other than John Treasure Jones, the *Queen Mary's* last master and the one who turned her over to Long Beach. This spirit has been seen many times in this area but always vanishes when approached. There have been reports that the smell of cigar smoke precedes this apparition, and it is well known that Captain Jones loved a good cigar. Jones, if it truly is he who

Inside the *Queen Mary* propeller box. *Courtesy of Dave Twolen.*

haunts this area, may be concerned about the two big holes in the side of his ship.

The spirits of two girls, Jackie and Sarah, have been reported wandering this area as well. The Royal Theater is directly across from where the propeller box is located and where Peter James first made contact with Jackie back in 1991. Sarah likes to play with and protect little Jackie, so it is not unusual to find them together. The girls have been heard running and laughing just outside in the hallway and have been heard and spotted in the museum area just forward of the propeller box exits. This area has many

re-created cabins from the *Queen Mary's* sailing days, as well as World War II troop accommodations and scenes of what life aboard the grand ship would have been like, and the girls may look at it as home in some way.

The Lady in White has been known to frequent this part of the ship as well and is most likely keeping an eye on the two girls. Grumpy has also been heard here, which makes people wonder if he, too, is following the two little ones as they wander the ship. There are other spirits that have been reported in this area, but no one has been able to pinpoint who they might be, but if you come across Captain Jones in your wanderings around this part of the ship, try to assure him that his ship is safe and thank him for always looking after her.

BOILER ROOM/GREEN ROOM

Once the heart of the RMS *Queen Mary* had been removed—I am speaking, of course, of her Yarrow boilers—there were huge areas of empty space below the passenger decks that at one time were to house the "Museum of the Sea." The museum was a bust, however, which just left the empty space to contend with. The forward engine room and part of the boiler room just in front of it were converted into the Exhibit Hall, and in front of that was the Boiler Room Stage. This stage was a venue for small concerts and shows and was later converted into a nightclub. Being away from the main sections of the ship, a room was needed for the actors and musicians to change clothes, relax and have a place away from the audience. Creating the Green Room in the smaller, now empty generator room just forward of the stage did this. It just so happens that this generator room is a favorite hangout for the spirit known as John Henry.

John Henry is said to have died in this area of the ship, possibly along with another man, back in the early 1930s. John is another spirit that is known to prefer the company of women. Over the years, the Green Room has lost the identity for which it was originally created and has now become famous, or infamous, for its paranormal activity. Actors using the room have reported hearing the sound of knocking coming from the surrounding area, but no cause has ever been discovered. Others have reported disembodied whispers and banging on the walls of the room. There have been reports from the male talent using the room of being shoved while at the same time hearing a voice telling them to get out.

This has caused many to abandon the show, giving up their pay and disappointing the guests who were gathered to see them perform. Women seem to fare better than the men who come here, and the female actors have told of hearing soft humming coming from nowhere and have felt light touches on their hair, arms and cheeks.

Well known as one of the hot spots for paranormal occurrences, this little room has received quite a bit of attention over the years from ghost hunters and investigators alike. In that time, reports have been made of seeing someone staring down from a small square hole cut into the ceiling of the Green Room, but when a flashlight is directed at the hole, the face quickly retreats. In each account, the face looking back at the investigators is that of a rugged-looking man. Could this be John Henry or perhaps the other welder that Peter James has said may have died near him? Another odd phenomenon that occurs in this area is that even though the whole area is very dark, there are times when the darkness seems to thicken and gets darker than it should be. One can still see the dim lights high above, but the surrounding area grows so dark as to be unnatural. As quickly as the darkness comes, it departs.

The Green Room is not haunted; it is the generator room itself that is haunted. The Green Room just happens to be the spot where people investigate most within the generator room, so it has garnered the most attention and fame. Standing on the wooden walk that runs past the room, people have heard knocks, bangs and the sound of work being done in the surrounding area, even though there is no one there to do the work. The first-class pool is directly over this area and could be one of the reasons that people have heard the voice of a little girl coming from the dark recesses of the room. This child is not Jackie, however, and has been heard quite often, along with the voice of a small boy. Jackie has been heard here also, along with Grumpy and possibly Sarah. Strange balls of light have been seen, as well as the twinkle from some strange, unknown source.

Just outside the Green Room is a series of steep stairs that leads to a platform directly above the Green Room and then up farther to the portside door, which leads into the pool itself. On this platform, people have reported seeing what appears to be a figure crouched in a hatchway on the starboard bulkhead below. This figure will stare back and then move out of view; at other times, a voice can be heard telling those present to leave the platform. People have reported sounds on the staircase itself. There have been times when you can hear someone moving up or down the stairs, but upon investigation, it is found that there is no one present. As the top of the

stairwell is blocked off, it would be hard for anyone to hide or move off the stairs without being noticed or heard from below.

Whether the spirit here is that of John Henry, the other welder who possibly perished with him or both, one thing is certain: they don't seem to be shy in letting us know that they are still present on the *Queen Mary* or that they much prefer women over men. When you are in this area and happen to see or hear our two evident entities, be careful not to upset them if you are male and maybe flash them a pretty smile if you are a lady and let them know you are aware they are there vying for your attention.

THE BRIDGE

The bridge is, of course, forward on the command deck and is the location from which the captain and navigation crew would guide the stately RMS *Queen Mary* on her voyages. This could be considered one of the most important rooms on the ship, and the captains and their crew members would spend a great deal of their time here. Important decisions were made here that would affect everyone on board, so emotions ran high. This might be one of the reasons that this bridge is a paranormal hot spot.

From the time that tourists were allowed on the ship, people claimed to have seen a spectral crew manning the helm and an officer pacing the wheelhouse. Many times over the years, these guests would ask about the "actors" they had seen, only to find out that the ship employed no one in that capacity. Investigators have witnessed this same officer in the wheelhouse, as well as on the flying bridges on either side of the ship. It is a widely held belief that this ship's officer is none other than Captain John Treasure Jones himself.

Captain Jones was completely dedicated to his command and may have, after spending forty-seven years at sea, decided to spend the afterlife on the ship he loved the most. Those who have seen his spirit have described him as he looked the day he took command of the ship, and photographs have borne out that description. The senior officers' quarters are on the deck directly below the bridge, and Jones has been spotted there also. The smell of cigar smoke oftentimes precedes the arrival of Captain Jones, and nowhere is this more evident than in his old living quarters.

There is another officer who has been seen in the area of the officers' quarters even though he was not housed here himself, and that is Senior

Second Officer William Stark. It is unclear what he is doing wandering this section of the ship, but there are those who believe that he is looking for the captain of the watch who directed him to entertain the two new junior officers. The reason behind this search is unclear, however, and one can only speculate about the reason he is seen in the living area.

The bridge was, as stated, one of the most important areas on the ship and was where the bridge crew kept the ship safe from hazards such as icebergs, U-boats and other ships that may have inadvertently crossed the *Queen Mary*'s path; as such, the crew members had to always be on alert, and tension was a constant companion. With this in mind, if you happen to see Captain Jones or any of his crew members still at work keeping the *Queen Mary* out of harm's way, stay out of their path, but perhaps say a thank you for all of their hard work.

PROMENADE DECK

The Promenade Deck was the gathering spot for the wealthy passengers to be seen and for those looking to see any celebrity passengers who may have been sailing on the *Queen Mary*. At any given time, there were travelers strolling up and down the polished teak decks or sitting in posh wooden lounge chairs, shopping in the stores of the Piccadilly Square area or just lounging in one of the many sitting rooms, garden rooms or libraries. In the evening, the Observation Bar at the front of the Promenade Deck was filled with guests listening to music and enjoying cocktails, and the Queen's Salon just aft of the shopping area rang with the sound of bands playing, people dancing and comedians telling jokes. It truly was the hub for social activity on the grand liner, and even today some of the passengers and crew of yesteryear still wander the wooden deck in search of the gaiety they once remembered.

The Lady in White is often seen dancing the night away in the Queen's Salon to some unheard music, her white gown flying about her as she twirls. People have said that it sometimes appears that she has a partner, and at other times, she seems to be dancing alone. No one has ever been seen with her, so one can only speculate about her invisible suitor. The Lady in White is described as young and very beautiful and has on occasion given guests a warm smile before she vanishes from view. She has also been seen out on the Promenade Deck, strolling along as if she hadn't a care in the world.

This lovely lady has been seen in the Observation Bar, Promenade Café and many other areas on this deck as well.

During World War II, Winston Churchill sailed on board the *Queen Mary* more than on any other ship, and he would often work in his stateroom, but when he wanted to get away from its confining space, Cunard had an office set up for him up on the Promenade Deck. Today, the Queen Mary Store occupies this space. Over the years, many people have claimed to smell cigar smoke while shopping in the store and, on rare occasions, have even spotted Mr. Churchill standing by the fireplace that was at one time directly behind his desk.

One of the more common spirits to be seen on the Promenade Deck is that of Senior Second Officer Stark. This poor soul has been spotted wandering up and down the deck almost as if in a daze; it is strange that he is described differently when seen on the Promenade Deck than when he is observed near the bridge or even by the officers' staterooms. Stark has been spotted in many areas of the Promenade—so many, in fact, that one should keep his or her eyes open anywhere on this particular deck.

Captain John Treasure Jones is another crew member who is seen often on the Promenade Deck. Unlike Stark, however, Captain Jones carries himself with an air of authority that is unmistakable and marks him as the master of the vessel in a way that one cannot deny. Jones has been known to nod his head at onlookers in a pleasant "hello" and then will simply vanish from view.

Shadow figures have become a common occurrence on the Promenade Deck, as has the occasional sighting of spectral passengers strolling along as if they were still on their transatlantic voyage. There are also reports of a modern-day spirit, but as this death is still a fresh occurrence, we will not dwell on this sad incident.

When you visit the *Queen Mary,* you will inevitably find yourself on the Promenade Deck and walking the teak decks, as have all those who came before you. Just remember that those others you see strolling along with you may not be who you think they are. They just may be past travelers still wandering the deck in search of the rich and famous, hoping to catch a glimpse of their favorite actor while sailing on the "Stateliest Ship Afloat."

SIR WINSTON'S

Sir Winston's is by far the best restaurant on board the *Queen Mary* and possibly one of the best in the city of Long Beach. This gourmet eatery

just above the Verandah Grill at the stern of the ship is known for its filet mignon, beef Wellington, Dover sole and impeccable service. There is one other thing that this five-star restaurant is known for, and that is, of course, its spirits.

Over the years, guests have reported smelling cigar smoke while sitting at the bar, even though smoking is not allowed anywhere on the ship, and many people have complained to staff about the odor. Employees would look for the offender, but to no avail, and the cigar smoke would continue unabated. It is believed that this phantom smoke may be coming from Winston Churchill himself. Churchill has been seen on rare occasions in the bar area but always quickly disappears from view.

Another patron of Sir Winston's bar is a spirit known simply as "the Dude." This wealthy gentleman, in a top hat and tails, will approach guests in the bar, clear his throat and then simply vanish. He has also been seen disappearing through the wall that leads into the men's restroom or simply sitting at a table watching the other diners with a mischievous smile on his face. It would seem that he is a prankster and spends his afterlife surprising unwary living souls for his own amusement.

David and Sarah are a couple spirits who are looking for their lost children. They are seen standing off to the side just watching as guests go by with a curious look on their faces almost as if they want to ask a question of the passersby. Rob and Anne Wlodarski were the first to communicate with these specters. During their conversation, they found out that they were looking for their lost children. People have tried to approach the couple, but each time they will disappear and occasionally reappear in another part of the restaurant. It is hoped that they will eventually find their children and attain the peace that they deserve.

FORWARD CARGO HOLD

The forward cargo hold of the *Queen Mary* is by far one of the most haunted sections of the ship. Now off limits to guests and investigators alike because of insurance concerns, it still remains a bucket list item for any investigator who has not been lucky enough to experience this location for him or herself—and even for those of us who have been there many times. At one time, this area of the ship was featured on two of the paranormal tours provided by the *Queen Mary,* and many of the participants came away from

The forward cargo hold. *Courtesy of Planet Paranormal.*

the experience in a state of awe about what occurred there. Return visitors are highly disappointed that the hold has now been quarantined, but because the ship has so much more to offer, they still book the paranormal tours on a regular basis.

There are a few reasons why the cargo hold is so active, not the least of which is its history of prisoner-of-war deaths that have occurred here. During World War II, German and Italian prisoners of war, along with other enemy combatants who were being sent to the United States for internment were transported in this hold. Prisoners were assigned a bunk that they had to share with one or more fellow prisoners; this caused them to have to sleep in shifts. Being in the very bottom of the hull and at the very fore of the ship, the trip in the forward cargo hold was rough, cold, damp and very dark throughout the voyage. Because of these dreadful conditions, many of these prisoners of war perished during the transit. Some developed ailments such as pneumonia, others died due to violent weather slamming them into the walls and deck and still others were killed in simple fights with their fellow captives.

One deck above the entrance to the cargo hold is a storage room that at one time was used as a makeshift morgue, and next to that is where the

prisoners' medical ward had been set up. The British were enemies to the German and Italian troops at the time and had a tendency to treat them with standoffish rudeness; they were not brutal in their treatment, however, and would send doctors and nurses down to this primitive medical ward to tend to their illnesses and injuries. Many investigators and tour guests have reported hearing the voice of a woman with a British accent down near the cargo hold and on the decks above; it is believed that this wayward woman may be one of the nurses sent to aid a sick or injured prisoner and may have died during rough weather or some other violent act. The morgue in this area may also be one of the root causes for the high amount of paranormal activity in this section of the ship.

Perhaps the most tragic event to ever occur involving the RMS *Queen Mary* happened on October 2, 1942. As we mentioned in an earlier chapter, this is the date the *Queen Mary* sliced into the HMS *Curacoa*; the resulting collision broke the back of the smaller escort cruiser and ripped her literally in half. The resulting deaths of over three hundred of the *Curacoa's* crew members makes this one of the worst disasters in British maritime history. Being very close to the spot where the collision occurred, the cargo hold may have absorbed some of the human fear and terror that those poor sailors felt as they were sucked up into the gaping hole of the giant liner only to be spit out and pulled under the massive hull, with some being chewed up by her huge brass propellers and others simply drowning as they banged along her bottom. Over the years, many people have claimed to hear the sound of rushing water spilling into the ship, accompanied by the sounds of men screaming in abject terror. The paranormal tour guides have said that this a common occurrence and have tried to calm their guests, but some have fled, thinking the ship was about to sink. The only explanation for this terrifying phenomenon would be the sad case of the *Curacoa*.

Some of the other paranormal reports from around the cargo hold area include voices heard by investigators while in the hold itself, as well as on the platform just outside the hold's entrance. Many of these voices are heard audibly, and even more are caught as EVP. These voices have been heard in many languages, but the most common appear to be German and Italian and, of course, English. There have been times when the voices can be heard talking about the investigators and asking one another who the investigators are and why they are there bothering them. The most curious of the voices seem to speak with a British accent, and many people believe that these curious specters are some of the lost crewmen of the ill-fated *Curacoa*.

Many people have seen balls of light flying around the cargo hold and have speculated on what these may be. They move as if they are alive, darting about, dipping up and down and then disappearing or sometimes passing out through the open door above the ladder. There is also an odd phenomenon involving what people say looks like sparks that seem to cascade from the ceiling. They have been described as akin to welders' sparks, but no known cause can be ascertained about where they emanate from. They will fall for a few minutes and then simply just stop. There are no electrical plugs in this area of the ship and only a few very dim utility lights, but there seems to be no correlation to these fixtures and the waterfall of sparks.

With all of the suffering and death that took place in this tiny section of the hull, it should come as no surprise that it would be filled with restless souls. If you ever have the good fortune to get to tour this area or to actually investigate here, please remember that the war is over. Keep this in mind if you see people who seem out of place or hear the plaintive sound of men in distress, and if you hear them speaking another language, try to console them, especially if you find they belong to the HMS *Curacoa*.

THE FIRST-CLASS POOL

This room on the RMS *Queen Mary* has become almost a shrine to paranormal investigators. It is said that a vortex here is allowing all the spirits to cross over into our realm and back again. This is where investigators come to try to find Jackie and her entourage, to speak with the poppet and try to pass her on to the next step of her existence. They gather round the pool with toys, candy and stuffed animals in an attempt to coax her to action and sing "Ring Around the Rosie" to get her to play with them. Many leave disappointed, while others find that she was there but remained aloof to their pleas. In short, this may not be the most haunted room on the ship, but it is the most visited.

The *Queen Mary* was one of the first ships to feature not just one but two lavish indoor pools. The second-class pool was placed at the stern of the ship near the machinery and was accessible only by the second-class passengers. The first-class pool, however, was available to not only first-class passengers but the third-class passengers as well. There was a restriction on the lower class, however: they were not allowed to access it until after 7:00 p.m. The reason that they were able to use this pool was due to its proximity to the

The apparition of a girl caught in the first-class pool changing rooms. Creepiest picture ever! *Courtesy of Brandon Alvis and APRA.*

front of the ship, where all of the third-class passengers were berthed. This pool was located just forward of the first-class dining room and just aft of the third-class dining room, with its entrance on R deck accessible by an ornate doorway while the pool itself was one deck below on D deck. The balcony level also held the widely popular Turkish baths and had a beautifully designed flared staircase that led down to the pool and the now infamous changing rooms.

I say infamous when describing the changing rooms because that is where the dimensional vortex is said to be. This portal to the other side is purported to be located in the narrow aisle between the changing closets, three stalls back from the port side. It is said that if you stand at this spot, you will feel the hair on the back of your neck and on your arms rise, your skin will crawl and eventually you will begin to get dizzy. People have claimed that when they are near this spot, they get the feeling of being watched, their adrenaline will start to pump uncontrollably and they will have a strong urge to flee the cramped changing room area. People who have investigated this area have reported hearing the whispers of a little girl and a British woman and seeing the shadowy apparition of a man who will watch the investigators intently before vanishing from sight. There are many tales of a spectral cat that prances by as the people sit in the stalls and even, on the rare occasion, will brush up against those it seems to like in the way that cats do.

There is another dark and eerie place in the poolroom that has a tendency to unnerve tour guests and investigators alike. There is a small room directly under the staircase at the front of the pool accessed from a very narrow, very low aisle to port—so low, in fact, that one must stoop to enter the room

itself. This area is the home of Grumpy the Growling Ghost. As mentioned earlier, no one is quite sure who Grumpy actually is, but it is a certainty that he is most comfortable in his home under the stairs. Many people have heard Grumpy as they approach this small room, and some have even reported seeing what appears to be glowing eyes looking back at them from the dark. There are many times that investigators will be conducting an EVP session in this room and they begin to get a feeling of dread or fear, which will continue to rise until they are forced to flee the confines of the tight little space. This feeling of foreboding could be transference from Grumpy and could signify that the story many psychics have put forth of this spirit having murdered someone and his subsequent guilt and eventual suicide may be true.

The main room of the pool is an Art Deco masterpiece with tiled columns, walls and floors, and its domed ornate ceiling is a study in grace and beauty. The pool itself can no longer safely hold water, but one need only look at the short slide, wooden ladders and tiled steps to understand what it must have been like to share a dip with fellow travelers while the mighty ship cut a course across the Atlantic Ocean. This camaraderie of adventure and fun

A possible apparition near the main pool entrance. *Courtesy of Dave Hoover.*

may be the reason some of the past passengers have decided to remain and continue to frequent the pool.

Since the *Queen Mary* has been open as a hotel and tourist attraction, the pool has become famous for its haunting activity. Once used as the hotel pool, guests would go in for a swim and feel the presence of someone in the pool with them even when they were alone in the room. Wet footprints would appear out of nowhere on the tile floor, and the apparition of a woman wearing a 1930s-style bathing suit would be seen exiting the pool and walking into the changing room. After the pool closed in the 1980s due to stability concerns and attractions made it a permanent part of the historical and paranormal tour route, many guests continued to see the wet footprints and, on rare occasions, the spirit that left them. Unfortunately, as the tale of the spectral bather became more and more famous and widely known, the management of the ship decided to capitalize on this phenomenon and created special effects to re-create the ghostly experience. Since then our bathing beauty has become more rare as the years go by.

There is an entrance from R deck, forward of the pool, where guests enter for the Ghosts and Legends tour. People walking down this hallway have been surprised to hear the melodious voice of a young woman singing and the sound of an even younger child humming along with her. It is believed that this woman singing is the Lady in White and the child is Jackie; others believe that the woman is Sarah and that she has somehow transformed herself into a much older person to help soothe little Jackie. There have been times when investigators have heard the singing and then a very loud growl, which occasionally causes the child to scream out in terror. It is believed that this growl comes from Grumpy, but why he appears to be tormenting the little girl with these outbursts remains a mystery.

The Lady in White has made herself known here by speaking and singing audibly and has been fairly talkative in EVP recordings as well. Grumpy moves away from his hiding place under the stairs and will growl right up against people's ears, close enough that visitors can feel their lobes vibrate. Sarah usually does not like to make herself known, but when she does, it is most often to try to get people to leave her alone. She is not very sociable and has become almost violent in her assertions. Captain Jones has been spotted here, and as of late, Peter James, the "paranormal father of the *Queen Mary*," has been heard and photographed here as well. Peter James's last wish before he died was to have his ashes placed aboard the ship he loved, and for a short time, that was exactly

what he got. However, allegedly one of the management groups that had subsequently taken over operations decided that it was not appropriate and demanded that his family remove Peter from the *Queen Mary*. It would appear from what we are now discovering that even though Peter's ashes may have been removed, Peter himself has remained. For those of us who will forever hold him in highest esteem, we are grateful that he has stayed on to watch over the ship and her spirits.

A Pinch Out of Time
As Told by Nicole (Last Name Withheld)

When I entered the ship, I immediately felt the name Sarah coming to me. I didn't know where it came from, and I joked to my husband that I was curious if that name would be mentioned during a tour or elsewhere during our visit. I felt she was a young girl. The first stop on our tour was to one of the cabins, where a man died under suspicious circumstances. Just before we entered the room, I felt a strong pinch at my right arm, and after that my whole arm got numb and started to tingle. I rubbed my arm and thought, "Ouch." When I walked into the room where this man died, within three seconds I turned around because I was overwhelmed by the feeling of dread, and I felt I needed to throw up. For some reason, I got the feeling something "dark" was present there. I don't like the word demonic, but there is no other way I can describe what I felt.

Like you guys from Planet Paranormal, we went to the first-class swimming pool. The energy in that room was high, and the air was thick. I walked down to the dressing rooms, and almost at the end of the dressing rooms, I felt the energy shifting and felt as if I walked into an invisible wall. The guide told us it was a portal where spirits come and go. I felt it, and it scared me.

When we left the *Queen Mary*, I felt as if the energy was sucked out of me. I had a terrible headache and felt cold and uncomfortable. Later, when we got home, I took a bath, and my husband asked me about my arm. We both looked at my arm, and sure enough, exactly where I felt that pinch, I had three weird pinpoint bruises. The picture that we took is not as clear as it is when you look at the bruise, but I'm certain the bruise wasn't there before we went on the *Queen Mary*.

HALLWAYS, GUEST ROOMS AND EMPLOYEE AREAS

Previously, we told you about the hot spots of the RMS *Queen Mary*, those areas of the ship where tours are given and investigators go to find spirits that hopefully have something to say. It is true that those places have a high amount of paranormal activity going on, but what about the rest of us who, after the tours are complete, want to explore on our own but have no team to help defer the costs of the investigation and can only wander the ship in the hopes of contacting the other side? Fear not, because the *Queen Mary* is not just the sum of her places but also a living piece of history that has spirits of past passengers that can and will make themselves known anywhere and everywhere on the ship.

We cannot tell you how many times we have spent the night on the ship and have had activity in our rooms. Granted, this does not happen every time, and we have gone months without anything happening at all, but on the whole, it is common enough that we would say just staying on the ship and enjoying her everyday activities can bring about an unexpected event that may satiate your desire for the paranormal. We have heard tales from

Shadow person caught outside Grand Salon. *Courtesy of East Valley Paranormal.*

many of our friends who stay overnight about their ghostly encounters, and our "Queen Mary Shadows" site and Facebook page have many more stories from people all over the country and the world who have had visits from the *Queen Mary*'s cadre of happy haunts.

Oops, Wrong Room
As Told by Bridget Emery

On one visit to the *Queen Mary* with my daughter and her best friend, I decided around midday to book a room for the night. Later in the day, however, my daughter and her friend were getting tired and wanted to head home. It was too late to cancel my reservation, and besides, I wanted to stay in the room, so I figured I would just drive the forty-five minutes back home and then return to the ship by myself. After the ninety-minute drive (phew!), I arrived back at the *Queen Mary* and did a little bit of walking around the ship.

I was getting tired by evening and decided to retire to my room; I should mention here that I had forgotten to pack an overnight bag, so when I showered, I laid out my clothes, washed my undergarments and hung them over the shower rod to dry. I then wrapped myself with a towel and curled up in bed to watch some TV. I fell asleep around 9:00 p.m.

I awoke around 11:10 p.m. and sat bolt upright in bed. There, standing in front of me was the figure of a man in a dark suit and wearing a hat! I knew that this was not a live person but a ghost, as I have seen spirits before. He did not look like a full-color person but more of an ash gray color. I was frozen like a deer in headlights.

"Sorry, wrong room," he said and then turned and walked right through a locked door in the wall.

The next morning, I mentioned this incident to the front desk staff, and the clerk stated that this was the second time that week that someone had reported seeing the same man in their room.

Apparently, this spirit was making the rounds!

The hotel rooms are not the only places on board the *Queen Mary* where random paranormal events take place. There are many event halls, meeting rooms and banquet halls where the spirits like to congregate and have been

known to surprise the unwary. This includes the capstan room at the stern end of A deck. Reports from this room vary, and there have actually been reports of *Titanic* crew members and passengers being spotted in this once machine- and capstan-filled space. The Britannia Room, once the second-class lounge at the back of the main deck, has seen the apparitions of both men and women in period clothing, as well as men in military uniforms wandering about or simply sitting and enjoying their time aboard. The Queen's Salon has already been discussed, but it is also one of those rooms that may be viewed at almost any time of day or night without having to take a tour. Its central position on the Promenade Deck makes it one of those places visitors can easily investigate to their hearts' content. As we mentioned, this is one of the favorite spots for the dear Lady in White to dance the night away. As this salon is on the Promenade Deck, visitors should also keep their eyes open for Mr. Stark and Captain Jones as well.

The Observation Bar at the front of the Promenade Deck is open late, and many hotel and event guests hang out there until closing. Even though the bartenders are serving up spirits in tumblers and beer glasses, many other spirits have been talked about as well. Once a hub for social activity on the long trips across the Atlantic, it would seem that some of the past passengers have returned to carry on their revelry and don't seem to mind who sees them.

The Grand Salon sits across from the entrance to the first-class pool and was originally the first-class dining room. Its Art Deco décor has remained, and it is one of the most beautiful remaining original rooms on the ship. During World War II, it was used as a mess hall for troops going to and from Europe, and the port side of the dining hall was converted into a hospital ward for wounded GIs returning home from the battlefields. As hard as the doctors and nurses worked on these men, many would pass on before reaching American soil, and some of those men have chosen to remain on the *Queen Mary*. There have been reports of phantom GIs wandering the room and what appears to be waiting in line for meals. People have also stated that they have seen past passengers milling about in their finery and occasionally dining around what should be empty tables, talking with one another while enjoying their meal. It is the kitchen of this dining area that is home to our spectral cook as well.

The hallways of this mighty liner have seen countless people come and go, and many of the past passengers and crews have remained behind and still wander the decks. Today, reports of shadow figures that lurk in the dark recesses of the corridors are common, and sightings of spectral travelers

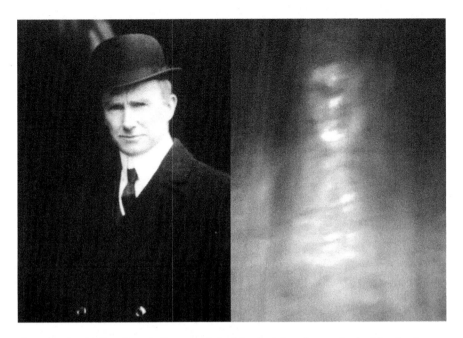

Could this be the late Captain Rostron of the *Mauritania* hanging out in the Mauritania Room of the *Queen Mary? Courtesy of Gerald Reynolds.*

occur frequently. The cries of unseen infants can be heard around the third-class nursery, and crewmen have been seen just going about their daily chores as well.

All of these tales should be in the front of every guest's mind as he or she wanders the halls and rooms of this wonderful old Queen of the Seas.

Chapter 8
TALES FROM THE DOCKSIDE

The *Queen Mary* has been known for years as a haunted ship, and ghost hunters and paranormal investigators alike have flocked to her to see if they could find evidence of life after death. There are those visitors to the ship who have come just to take the tours and have a bit of fun while learning about the liner's storied past and resident spirits. Then there are those who have come for a good night's sleep, never dreaming that the tales told of spooks and specters are in the least bit true. There is one thing that all of these people have in common, and that is the fun or fright of either finding what was searched for or realizing that what they believed to be folklore and legend was actually true and now undeniable. In the following chapter, we give you just a small taste of what these people have seen and felt but make no claim about the accuracy or validity of the reports given. It is up to the reader to decide and enjoy.

A TRAIL OF GHOSTS
AS TOLD BY DAVID A. GRUCHOW

On Saturday, January 19, 2002, a group of thirty dads and daughters from the Yorba Linda YMCA Trail Mates program had arranged a one-night sleepover in the *Queen Mary*'s staff Training Center at the stern of the ship, above the engine room. After a full day of touring, including the excellent

Ghosts and Legends tour, we laid out our air mattresses and sleeping bags and began to get ready to turn in for the night. The goofy teenaged girls in our group had covered the entire room with thin plastic streamers in a crisscross pattern from wall to wall about four feet off the floor. They said this was their "ghost trap."

At 1:25 a.m., I was awakened by a low, moaning cry that reminded me of the sound a sleeping person makes when he is having a particularly bad nightmare. Dismissing the sound as simply one of the hundreds of noises a big ocean liner can make, I tried to go back to sleep. When the noise occurred again a few minutes later, I sat up and looked around, but nobody else in the room seemed to be stirring. When the cry sounded again a few moments later, I saw one of the other dads in our group jump up out of his sleeping bag and run out into the hallway near the Royal Theater to look around. When he came back, we looked at each other, silently shrugged our shoulders and shook our heads as if to say, "What the heck was that?"

Ten minutes later, the cry came a fourth time, but it was much louder and sounded as though it was right next to me. I got huge goose pimples all over and an unnerving chill in the pit of my stomach. I must admit that by this time I had my sleeping bag pulled over my head and didn't have the courage to peek out. Naturally, I didn't sleep at all the rest of the night.

The next morning over breakfast, everyone scoffed at the three of us who claimed to have heard the cry. Even today, I don't have a clue about what that sound really was. I guess it could have been anything, but it sure was creepy! And it sure makes for a GREAT story!

CALLED TO THE CARPET
AS TOLD BY JOE AND VICI RUFFULO

Vici and I have stayed on board the *Queen Mary* several times and have experienced many unexplained events in our room and around the ship. One morning, we were getting dressed and heading out for breakfast. I was gazing out of the porthole and snapping a couple pictures of the Long Beach skyline while Vici finished up in the bathroom. She was just about to step out of the shower when the bathroom door flew open. It did not open slowly, and it slammed against the wall really hard. Vici asked me if I had done this, and of course, I said, "No, I was taking pictures out of the window." We tried to debunk this by gently closing the door

without latching it, but no matter what we tried, we couldn't get the door to open on its own.

On another trip, we were attending a paranormal event on the ship and had heard that we could request a haunted room when making our reservations. Upon checking in, we asked the front desk if our room was haunted, and they told us that it was and what had been reported within the room. After unpacking, we decided to rest up before walking around the ship but were surprised when the light in our room turned off and then back on again. We really didn't think much about it until it happened again and then we just looked at each other and smiled. After we rested a bit, we decided to go topside and take a walk. As we left the room, I turned off the TV and headed for the door. Just as we were about to walk out, the TV turned itself back on, and again we just smiled at each other, as these were exactly the things that the front desk had told us were reported in this room.

Once we left the room, we headed down the long hallway on our way to the main staircase. Anyone familiar with the guest rooms knows that the doors are recessed down a short hallway. As I was approaching one of these, I spotted the shadow of a person on the carpet as if they were coming out of their room, so I stopped to make sure we wouldn't run into each other. I waited a second, but no one came out, and when I looked down toward the door, there was nobody there. The shadow had just disappeared.

Hide-and-Seek
As Told by Cornelia Heun-Davidson

In 2010, I went on the first private investigation night on the *Queen Mary*. It certainly wasn't my first time on the ship, as I had worked on board for three years almost twenty years earlier. There are many spirits with whom I've had a long-term relationship, and going to the ship is like going to an old friend's house. Several of us in the group have a bond with two girls named Jackie and Sarah. Even though I have a closer relationship with Sarah, I play with Jackie when she is in a playful mood, and when we were in the first-class pool this night, we felt that the girls wanted to play. We were also eager to get audible responses from them through play, so Liz Johnson joined me in a game of chase with the girls.

We started off on the lower level of the pool area with Liz and I first walking around the pool feeling Jackie and Sarah about fifteen paces in front

of us. After going once around, the girls made their way to the upper level, so Liz and I kept pace until we realized they weren't going to let us catch them. The girls thought this was funny, but we were getting worn out from running in circles.

Once we were on the staircase landing, I decided Liz and I should head in opposite directions. When I got to the top of the steps, Jackie and Sarah were close but ran off again quickly. Sarah tried hiding in the curved metal doorframe, but I stopped to let her run off again. Jackie hid by one of the columns to get away from Liz, so Sarah ran right back to where Jackie was hiding. Liz and I slowly approached Jackie and Sarah when they decided to end the game and stand there completely excited. The energy coming off those two was intense. Sarah stood there, completely breathless, and Jackie shouted, "Cornelia, you found me!" I didn't hear it at the time, but our friend David Harvey did through his recorder, and to this day, I still love hearing her say that!

A LESSON LEARNED WITH PETER JAMES ABOARD THE *QUEEN MARY* AS TOLD BY FRANK BERUECOS

Walking through the decks of the RMS *Queen Mary* is like stepping back in time, and the rich wood paneling that decorates the inside of her walls seems to harbor the history and energy of the past. I had made many trips to the *Queen Mary*, but this time I was very excited because I was personally invited on a tour of the ship with famed paranormal researcher and my good friend Peter James.

As I made my way to the stern of the ship into the Royal Theater, Peter met me and told me that just a moment ago he had felt activity inside. We had some time before the tour started, so we talked about his tours and some other more personal matters. As the tour guests arrived, Peter humbly welcomed them, and then once they were all seated, Peter began his tour in his usual energetic fashion by explaining the ship and her spirits, and from there, we went on to the hot spots of the ship.

When the tour was over, he invited me and a couple other people to stay behind for an extended tour, and it was during this part of the tour that we had a phenomenal experience down in the very bottom deck of the cargo hold. Peter mentioned that one of the ship's former captains was very active in this area, and Peter called out to Captain Treasure Jones to ask him to say hello. We immediately heard a deep male voice respond with a "hellooo" that resonated throughout the cargo hold. It was very chilling, especially

knowing that we were several decks below the water line and no one else was with us at that hour. Not all of Peter's questions had a response, but toward the end of our session, there was a "goodbye" that was clearly heard by all of us, which left us stunned.

Peter had developed a rapport with all of the spirits on the ship, and he strongly believed in treating them with respect and made sure that the spirits knew that he was not afraid of them. I believe this was why they responded so well to him each time. I remember taking an EMF meter out of my bag and turning it on and scanning the immediate area as Peter was asking questions. I did get a couple minor spikes, and I remember Peter asking me if the meter was showing any strong indications of activity, smiling while he asked. He later told me that he did not believe in using instruments, and Peter taught me how to use my body as an instrument, using all five of my senses. It made sense when he said that while we are so focused on the needle to move or the instrument to light up, we are missing what is happening around us; only if we are willing to open ourselves up will we see what is there. He taught me how to embrace spirits and not fear them.

THE SNORING GHOST
AS TOLD BY ERIN POTTER

My first investigation ever was on board the *Queen Mary*, and afterward, my husband, Leif, and I were back in our room getting ready for bed, and I decided to leave my recorder on all night to see if I could catch anything while we slept. I turned it on, placed it on the bedside table, and then Leif and I went into the bathroom to get ready for bed.

Later on that week, when I had some time, I played back the recording, and about five minutes into it, I caught two distinct EVPs. In the recording, you can hear the TV and Leif and me talking in the background about the evening's investigation. Then all of a sudden you can hear a loud snore. It sounded like a male walked up to the recorder and snored into it; you could even hear breath hit the recorder as the snore sounded. It then happened again about seven minutes later.

Unfortunately, because I was so new to investigating, I had purchased a recorder that didn't have a way to transfer the recording onto a computer, and still to this day, I have that recorder tucked away with those EVPs saved on it.

LOST GIRLS
AS TOLD BY KD FOREMAN

I expected it to be just a regular haunted tour on the *Queen Mary* with my paranormal team. We had brought along our K-II meters and our digital recorders and had teased one another about meeting a ghost on the ship. Needless to say, we were all filled with anticipation as we followed our tour guide into the heart of the ship.

As we approached the pool, I could sense a female spirit in the hallway, and while our tour guide droned on about the history and sightings in this area, my friend Brandi and I were busy watching our K-II meters flickering. Because I sensed a spirit, I called out, "Is there a female spirit in this hallway?" The tour guide stopped to answer me and said, "Yes, there is a female often seen in this hallway." Hot dog, this was going to be a great tour.

We moved into the pool area, where our guide told us of the common sightings of the little girl named Jackie. By this time, my K-II was really lighting up, and I figured Jackie was playing with it. I asked, "Jackie, is that you?" and the lights flickered. There was more chatter from the guide and something about following him out of the pool area and up some staircase, but Brandi and I were too busy with our K-IIs. Besides, I didn't want to leave the poolroom so soon. What if the K-II quit lighting up? Here was my chance for spirit interaction, and the tour guide was asking me to leave. "You can come with us, Jackie!" I said, hopeful that she—or whoever it was making contact—would leave her comfort zone.

I was barely aware that the last member of our group was going out the door but still managed to follow him out to the hallway and to the bottom of the stairway. The whole time, Brandi and I were intent on watching the K-II meters as they continued to light up. "Hurry up, you're losing the group!" called out one of our team members as he disappeared up the stairs. Brandi and I walked up slowly, still talking to the spirit following us, and said to it, "Thank you for coming along with us. Are you Jackie? Can you come upstairs with us?" That's when we reached the top and realized that we were now in the midst of many tourists, and our tour group was nowhere in sight.

We decided to go up another flight of stairs in search of our friends but to no avail. We went up yet another and found that here there were fewer people and a red rope with a sign that read "Employees Only." Now what? We assumed that since we had been with a tour group, that the group had probably gone past the rope on another leg of the tour, so Brandi and I

decided to follow. At the top, however, we realized that two things were obvious: one, our group was nowhere around, and two, we were in a "get into trouble for being here" zone. We could hear what sounded like carpenters working down the hallway to our left and the sound of heavy boxes being moved about and decided to head to our right. Unfortunately, this led to a dead end, so now what? We again moved off, this time to our left, heading toward the sound of the work and hoping we could sneak past. The whole time, we were monitoring our K-II and watching it light up while speaking as quietly as we could to encourage the spirit to continue communicating with us.

The entire time we were walking in this area we could hear the sound of people working with hammers and other tools, and when we reached the end of the hall, a dark curtain blocked our way. Brandi and I looked at each other and then flung back the curtain to reveal nothing, no one. Silence and calm was the only thing that greeted us. The room was empty, save for some boxes and some hardware, remnants of work done weeks, maybe months before. Brandi timidly called out, "Brandi and Kd here. Hello?" as we walked into the center of the room. Where were all of the workmen? Where was the noise we had been hearing for the last five minutes? Why was the room EMPTY?

We stood there wondering what the heck was going on when all of a sudden the noise sounded again, and it came from the room we were standing in. It was all around us, as if we were listening to a surround sound system. I was holding my breath, and it was almost as if time itself stopped moving. As ghost hunters, we wait a lifetime for moments like this, and now, I just wanted to run, but another part of me wanted to stay and investigate. My mind was telling me to go, and my heart was saying stay. It was at that moment when the noise simply stopped.

Brandi again called out, and this time voices rang out around us. It sounded as if fifty people were talking inside the room. We could hear what sounded like high-heeled shoes clicking on a wooden floor and then sudden silence once more. We decided to act like investigators and looked around for a possible cause for these sounds. We looked in the hallway we had come from and checked the overhead but could find no reason for the commotion. The noises did not return, and we reluctantly left the area to go find our tour group.

THE CAPTAIN'S INSPECTION
AS TOLD BY JACKI SPOTTS

We spent the night on the *Queen Mary*, and in room M-133 one July day, I had an experience I cannot explain. I will usually latch the chain in hotel rooms, but this night I didn't, and I'm not even sure why. It was around 2:10 in the morning when I woke up to the sound of the chain rattling back and forth, and when I looked at the door, sure enough, it was swinging as if someone had just released it. As I watched the chain, an apparition suddenly appeared between the wall and the end of my bed, and it was looking right at my roommate, who was still fast asleep.

The apparition was that of a captain from the waist up, and he was dressed in a white shirt and white coat, but it looked to be from the style that was popular in the 1920s or 1930s. He even wore a white cap with a black band around it (I was looking at him from the side), and he had short white hair and a very well-trimmed white beard and mustache. He looked to weigh about 225 pounds or so, but it was hard to tell with only half of him there at the time. I was just staring at him wondering if I was dreaming when he simply disappeared. After I got back home, I looked on the Internet to see if I could find this ship's officer but found that a lot of the captains of the *Queen Mary* didn't have photos, so I was unable to find out who he was.

THE UNFORGETTABLE HOTEL ROOM
AS TOLD BY CORNELIA HEUN-DAVIDSON

Back when Disney still managed the *Queen Mary*, it had a bon voyage party for the employees at the end of September 1992, and everyone was invited, including those who would stay on as part of a skeleton crew. I was part of the guest services crew that would remain until December. The employees made up more than half of the hotel occupancy on the night of the party, so I shared a room on A deck, starboard side mid-ship, with someone I was casually dating.

The party turned into a free-for-all, with plenty of food and alcohol for everyone. I wasn't old enough to drink but wanted the experience of staying the night in the hotel, so Jay and I stayed at the party until well after midnight, probably closer to two o'clock in the morning, before we retired to our room. The hotel room had two twin beds, but we shared the bed closest

to the portholes. I felt Jay get up to use the bathroom after a few hours, but I also thought he got back into bed afterward. Then, at about six o'clock in the morning, I woke, still feeling someone sleeping in bed with me. I had felt the blanket get pulled back as someone got back into bed not long after Jay went to use the restroom, and whoever it was just laid there as I drifted back to sleep once they were settled. I thought nothing of this until I woke up the next morning and saw Jay sleeping in the other bed.

My heart skipped a beat wondering who had decided to cuddle up with me in the twin bed when I looked up toward the porthole and saw a middle-aged woman and two men standing over the bed staring back at me. This wasn't the first time I had woken up to find spirits staring down at me. When I would take naps in the break room above the isolation ward, a muscular engine room worker or John Pedder would be standing over me; I felt like John and this other crewman were protecting me. This time, however, I looked at these three watching me and said, "Come on! Really? What's so fascinating about me?"

They vanished after I let them know their presence wasn't welcome in the room. I had not seen them before and wanted privacy. They made me feel uncomfortable and nervous so I got up and walked around the room to shake off the feeling that they would be back. I even took a drink of the whiskey Jay had brought to the room. I just kept thinking someone else would appear while I was showering and I watched television with the volume down to a slight murmur. When nothing more happened. I was finally able to resume my morning routine.

After staying again a few years ago, I realized it was Sarah who had crawled into bed with me, the eight-year-old girl who had died a tragic death in the first-class pool changing rooms. This is probably the reason I slept so soundly and wasn't bothered by her presence. I felt as safe with her as I did with the guy sharing the room with me.

Jay slept soundly through it all even with all the noise coming from me showering and then watching television until he woke up. I asked him casually how he slept, and he did say he dreamed about a little girl in our room. He knew Sarah is very close to me, so he didn't say much more. It was understood that I could get visitors no matter where I try to sleep on board the ship.

CHASING JACKIE
AS TOLD BY JAMES JOHNSON

I hadn't been to the *Queen Mary* for years, and as we approached for our "date night," memories of those past times came flooding back. This trip had come about due to my wife coming home one evening after spending time with her mother on the ship and telling me about all of the eerie feelings she had there and how it felt as if someone had been in the room with them the whole night. She told me how amazing the ship was and how haunted it felt. She explained how odd occurrences kept happening and that we needed to plan our own trip.

I am not a complete skeptic, as I believe in the afterlife; it's just I am not one of those who believe that every scrape or crackle heard on a recorder or spot in a photo is a ghost. I keep an open mind, and this trip would be no different. I was thrilled to go on the *Queen Mary* and explore a part of her history I had never thought about before. My wife had also told me that there were going to be several people who had been interviewed or written books and who have investigated the ship before. Heading up this group was Bob Davis, and he had been researching the ship for years.

We arrived at the ship, parked, checked in and headed to our room. The original appointments were unexpected, and I started snapping pictures, and my wife was saying that she already felt as if someone was hanging around, which had me snapping the pictures even faster. I began to settle down and was reaching into my bag when I felt a huge blast of hot air blow across my face. I looked for a logical reason for this but could find no rational cause and to this day am perplexed as to what caused it—unless, of course, I chalk it up to the one explanation most people find outlandish.

That evening, my wife and I explored the ship a bit, met Bob and a couple members of his group in the "Piano Bar" and had a few drinks before dinner. As we ate in the Promenade Café, we discussed some of the things we were to do this night, and then we all gathered back at the bar to get the night's investigation going.

The tour took us to many areas of the ship, and I was taking a ton of pictures the whole time. We were also turning our recorders on now and then while asking questions in the hopes of getting responses on our devices. The ship was awesome, the stories were fun and the people were laid back. The best part was that I was sharing this with my wife. What a great night!

The evening was winding down, and we were heading for our final location: the pool. It was around 3:00 a.m., and several things were

mentioned about the pool, such as that there was a vortex in the changing room, that there were roaming shadows and that there were even a couple little girls running about.

We arrived at the pool, and the first thing I noticed was that the lighting was very low. We spread out, with people sauntering about and asking questions to the unseen, and I started meandering about by myself. That's when things got a bit interesting. That's when I felt…something.

I have three kids, and even when I don't see or hear them, I know when they are near. This is the feeling I had, almost as if I was walking with my daughter near me. "OK, let's feed into this thing and play along," I told myself. I started to talk to someone I couldn't see, and all of a sudden, I felt a slight pressure on my palm, as if a child had taken my hand. As logical as I am, I felt compelled to separate from the rest of the group. I walked upstairs, sat down and began asking questions and playing into the whole experience. I can't explain how real the feeling was, but I kept hoping my wife would come find me.

Time passed, and she still didn't show, so I went and found her and took her back up to where I felt the presence. We began recording, and as I was telling my wife what had gone on, it happened, a sharp shriek from what sounded like an upset little girl. I asked my wife if she had heard that and was amazed when she said she hadn't. I quickly rewound my recorder to the spot, played it back and, clear as bell, you could hear the scream.

We went back downstairs and gathered everyone else into a group; no one else had heard the scream either, so I played it back for everyone, and the look on Bob's face when he heard it I will never forget. It was as if he had heard his own child's voice. He looked at me and simply said, "That's her. That's Jackie." Right after Bob made this statement, Joe and Brian came over with their recorders and said that they had caught the scream also. They both played their recorders, and sure enough, the scream was there. To this day, no one can understand why no one but me could hear it out loud.

My wife and I still ghost hunt to this day, and I have had many new experiences since that night, but I always long to go back to the ship, and when we are there, things are different now. We have many fun stories, revealing evidence and hair-raising moments, but to this day, like an addict looking for that fix, I'm still chasing Jackie.

HOP TO IT
AS TOLD BY JOLENE POLYACK

Over the summer, my husband and I traveled to Southern California with friends and stayed on the *Queen Mary* (QM). We were actually down there to NASCAR race in Irwindale but decided to stay a couple nights on the *Queen Mary* just to make a weekend out of it. We reserved spots for the Dining with the Spirits tour, which included dinner at the QM restaurant, Sir Winston's, followed by a late-night guided tour of the ship's paranormal hot spots. Unbeknownst to my husband and I until that weekend, the couple we were traveling with were seasoned paranormal travelers and had brought equipment to use during the tour.

When you check in at the front desk, you can ask and they will give you a list of all of the paranormal sightings both in the ship and in the hotel rooms. Unfortunately (or fortunately, depending on how you look at it), our room had no record of any unusual observations.

We got to our room, unpacked and then went to dinner with our friends in Long Beach. When we came back to the ship, our friends were ready to turn in, so we said good night to them and walked toward our room, which was much farther aft than theirs. Because the corridors are very long and narrow (we are on a ship, after all), my husband pulled out his iPhone and started taking pictures of me as I walked down the long hall to our room. It made a photographic shot that he thought was unique, and he took four shots in total. When we got to our room, he looked at his photos and asked if there was anyone in the hall with me. I replied, "No. No one. Why?" He said, "Are you absolutely sure? No one was in the hall with you?" Of course, being that we're on a documented haunted ship, I thought he was teasing. Annoyed, I answered, "No, just me. I already said no." He produced his iPhone, and I noticed that his hands were trembling. His hands trembling made my blood turn cold. I looked at the photos, and there I am walking down the hall toward our room. Next picture, again, is me farther down the hall. Then, me, farther this time, and a bellhop in a complete bellhop uniform walking toward me with his head tilted, as if he's helping me to find my room. Next shot, just me again, no one else in the hall.

We called our friends, and the four of us attempted a reenactment. We figured out where I would have been in all five shots, and there really is no explanation for how someone would have appeared in one shot that took place in between three others without my husband or me seeing him.

The next morning, we showed the photo to the front desk, and they confirmed that the uniform in the picture is not a uniform that has been worn on the *Queen Mary* by their staff to their knowledge. Later, as I was looking through a QM coffee table book in our room, I discovered a photograph taken in the early 1900s of the bellhops who serviced the ship back then. They are wearing the same uniform as the man who appeared in our photo—the same gloves, cap, brass buttons, everything. I am somewhat happy that I didn't see him in the hall that night, although it's unsettling because it begs the question of what else don't I see? Oh, and as for the Spirit Tour? That's another story…

WHO LET THE CAT OUT OF THE BAG? AS TOLD BY ERIN POTTER

My team, the Paranormal Housewives, had decided to have a meeting on board the *Queen Mary*. After our meeting, we decided to have dinner at the Promenade Café, and then my friend and teammate Kirsten and I decided to stay and take the early paranormal tour the ship offered. We were a bit skeptical about how the tour was going to go and wondered if they were going to highlight the "boo" factor or not.

When we arrived for the tour, we decided not to mention that we were paranormal investigators, and we could tell by the reaction of the other guests that they weren't either. As I said, we were a bit skeptical, but it turned out to be one of the best investigations I have ever had on the ship. Several paranormal things happened during the two-hour tour, but the most memorable was when we were sitting in the changing rooms in the first-class pool.

The tour guide took us back into the changing rooms and turned the flashlight off so we were in complete darkness, with the only light coming from the main room through the doorways to either side of the hallway. As we were sitting there, I all of a sudden saw the shadow of a cat. There is a tale of a spectral cat that hangs out in this area, and we were actually getting to see it. I called out, "Hey look, there's the cat!" The other tourists were seeing it also, and they were quite excited that they were seeing an actual ghost cat. The cat was slinking in and out of the stalls, slowly coming toward us, so I started to say, "Here kitty, kitty, kitty!" The cat then disappeared, and as we were looking for it, Kirsten yelped and jumped out of her stall and

right into the lap of our tour guide, who was sitting nearby. Kirsten then said, "The cat just brushed up against me!" At this point, the tourists and our tour guide turned on their flashlights, but the cat had disappeared.

I must admit that I thought it funny that the only person to get "scared" and yelp was my teammate, who was an actual paranormal investigator.

A BRIDGE TO THE OTHER SIDE
AS TOLD BY REBECCA ANN FOX

My team and I have been investigating the *Queen Mary* for many years and have gotten evidence from all over the ship. We have heard a little girl many times in the pool area, and even though most people will automatically assume it is Jackie, I have never heard her say her name, and even though she has responded occasionally when that name is called, as an investigator, I cannot say that it is actually Jackie or another little girl. What I can say, however, is that the girl is sweet and does like to play and sing.

We have recorded several different male voices in the pool area also, and one of these men seems to hang out in the changing room area. Most of the EVPs that we get from him seem to be cursing and telling us to get out. We have actually seen him hiding behind one of the stalls staring at us.

On the upper deck, just forward of the pool, there is a check/towel area where I have talked with another man who stands behind the counter. He is always a gentleman but seems confused by my abundance of questions. No one else seems to be able to hear him, but my recorder always captures our conversations.

The boiler room is another place where we seem to get a lot of recordings of what sounds like middle-aged men and a very harsh-sounding older man, all with English accents.

One of the most heart-wrenching things to happen to me on the ship happened on B deck almost twelve years ago. The entire deck was closed for renovation, and our team was walking down the hallway to the back of the ship when my sister and I heard the sound of a baby crying. We stopped dead in our tracks, but the sound grew louder and louder. The odd thing was that my sister and I were the only ones who could hear it. We raced up to the hotel desk, but they assured us that no one was staying in any of the rooms. They told us that the rooms had no furniture or electrical power. She did tell us, however, that they had been receiving calls from the vacant rooms even

though the rooms had all of the phones removed. A couple years after this event, I found out that room B-474 had been the site of a murder-suicide involving a man who had killed his entire family, which included a baby girl, and then killed himself.

The last place on the ship I am going to mention is the employee catwalk above the boiler room. This catwalk is suspended about one hundred feet above the boiler room and is made of metal with a mesh cage around it. One night, we were walking over this trying to make our way off the ship when I heard someone call out, "Becky!" I was confused because it sounded like my ex-husband, Joe, but he was far ahead of me, with five other people between us. I was the last in line and not yet off the bridge, while everyone else had already turned the corner. I hurriedly caught up with the rest of the group, and we went back to the bridge to conduct an EVP session. We each took a spot on the bridge; placed our recorders, motion sensors and EMF meters in front of us; and began our session. After only five minutes, we began to hear the sound of heavy footsteps coming toward us. We thought it must be security or another group of ghost hunters until we realized that the sound had reached the bridge, but we could not see anyone crossing. We could feel the bridge as it shook with the footsteps and hear the sound of boots as they got closer and could even feel the slight breeze as if someone were passing by. As each footfall passed by our equipment, the meters and sensors would go off and then abruptly stop as the sound passed. The sound never paused as it made its way across the bridge, and we believe that the spirit never even knew we were there. He was just going about his work and had a residual feel about him. Everyone with us that night was left with their fingers pointing in a "did you see that?" pose and their mouths wide open in amazement.

The *Queen Mary* never ceases to amaze me every time I am there.

EPILOGUE

The Queen Mary, launched today, will know her greatest fame and popularity when she never sails another mile and never carries another paying passenger.
—*Mabel Fortescue-Harrison, September 26, 1934*

The RMS *Queen Mary* is more than just a ship and more than just a museum, hotel or tourist attraction: she is nothing less than history itself. No other vessel ever built has done more or sailed farther while at the same time helping to save the world from destruction. No other vessel has brought more joy to so many women and children as the mighty *Queen Mary* when she brought them to their new homes and new lives. The men and women who sailed aboard her while immigrating have left their hopes and dreams buried in her lavish woods and polished decks, and the soldiers coming home from foreign battlefields have left their tears of joy to soak into the very being of the ship. Yes, the RMS *Queen Mary* IS alive.

Rusting and all but forgotten by those who are tasked to protect her, she sits in a lonely jut of land in Long Beach, California, waiting for someone to understand her and bring her back to full, vibrant life. On board are those past passengers still waiting for release and the chance to tell their stories, along with those who work there, just passing time, and who care little for the plight of this once great and proud relic of the past.

To those who have read this book, you give us hope that a new awareness of the ship might bring about the love and the will to help keep this piece of history alive for not only the living and generations to come but also for

those lost souls still aboard. For if our shortsighted need for profit allows this great icon of man's ability to achieve and overcome to perish, then how can we ever save our heritage or ourselves?

Thank you all for reading our work of love!

A Tribute to Peter James

Peter James was a gifted psychic and pioneer in the field of paranormal research. Peter was born in New York and first discovered his abilities as a child when he communicated with the resident child spirits in his apartment building. Through the years, Peter's psychic abilities flourished, and he dedicated his life to communicating with spirits and progressing paranormal research. Peter was best known for his fifty-six appearances on the hit Fox channel TV show *Sightings*, in which he traveled the country investigating reportedly haunted locations. Of these

The late, great Peter James. *Courtesy of Tuesday Miles.*

episodes, none was more popular than the Sallie House case in Atchison, Kansas.

In the early 1990s, Peter was given free rein of the RMS *Queen Mary,* and he was responsible for discovering the many ghosts that inhabit the ship, including Jackie, the talking ghost in the first-class poolroom. The entire conversation between Jackie and Peter was captured on videotape and

stunned the *Queen Mary* executives so much that Peter went on to become the resident psychic aboard the ship, hosting dinners and ghost tours for many years. I met Peter on one of his first tours, and we quickly became close friends.

On a personal level, I have to say that Peter was the most humble and warm person I have ever known. On several occasions, I was invited by Peter to tag along on his tours, and no matter how many people he had on his tour, he always made sure that every single person felt special by giving him or her one-on-one attention. I was fortunate enough to work with Peter on several other projects and locations throughout the years, and he helped me develop some of my own psychic abilities. Peter liked to explain the world of the paranormal and simplify it so much that everyone could understand it and not fear it. One of his famous quotes was "So in life…so in death." He encouraged those with psychic abilities to embrace them and not be afraid.

Peter's methodology is widely used by researchers in communicating with spirits by using thought-provoking comments to get a response from a spirit. He never believed in nor used instruments to detect paranormal activity, but he taught us how to use our bodies as instruments, utilizing our own senses. Peter believed that we live in a parallel world of co-existence with spirits and that it is our lack of understanding and knowledge that limits our ability to proceed more aggressively and openly when trying to identify paranormal activity and communicate. It was important for Peter that he leave a legacy behind after his passing. I believe without a doubt that he has paved the way for all of us. Peter was always quoted as saying, "To the believer, no explanation is necessary, and to the non-believer, no explanation is possible."

—**Frank Beruecos**

Frank was a close personal friend of Peter James, and we thought it only right that he write the tribute to this great man and his memory. Frank is a trusted friend of Planet Paranormal, and the times we have spent investigating with Frank are some of our fondest memories. Thank you, Frank, for taking the time to help us with this book. We look forward to many more adventures together.

BIBLIOGRAPHY

Cooper, Suzanne Tarbell, Frank Cooper, Athene Mihalakis Kovacic, Don Lynch, John Thomas, Queen Mary Archives. *RMS* Queen Mary. Charleston, SC: Arcadia Publishing, 2010.

Harding, Steve. *Gray Ghost: The RMS* Queen Mary *at War.* Missoula, MT: Pictorial Histories Publishing Co., 1982.

McAuley, Rob. *The Liners.* Minneapolis, MN: Motorbooks International, 1997.

Patrick Stephens LTD and *Shipping World and Shipbuilder. Ocean Liners of the Past: The Cunard White Star Quadruple Screw, North Atlantic Liner* Queen Mary. New York: Bonanza Books, 1979.

Potter, Neil, and Jack Frost. *The* Queen Mary*: Her Inception and History.* San Francisco, CA: San Francisco Press, Inc., 1971.

Steamship Historical Society of America. *"The Stateliest Ship* Queen Mary.*"* Staten Island, NY: self-published, 1968.

Watton, Ross. *Anatomy of the Ship: The Cunard Liner* Queen Mary. Annapolis, MD: Naval Institute Press, 1989.

WEBSITES

http://en.wikipedia.org/wiki/RMS_Queen_Mary.
http://planetparanormal.com
http://www.atlanticliners.com/rms_queen_mary_home.htm.
http://www.ocean-liners.com/ships/qm.asp.

BIBLIOGRAPHY

http://www.parainvestigations.com
http://www.queenmary.com.
http://www.queenmaryassociation.com.
http://www.queenmaryshadows.com.
http://www.queenmarystory.com.
http://www.ssmaritime.com/queenmary.htm.

ABOUT THE AUTHORS

Brian Clune has been an avid paranormal enthusiast for most of his life. He did not get involved with investigating until his son asked if they could go "ghost hunting." This led him to Planet Paranormal, which would forever change his life. Investigating became a passion, and the more he

Brian Clune (right) with Bob Davis. *Photo courtesy Don Shy.*

learned about what was involved, the more he realized that history was the key to effective paranormal discovery. His dedication to learning the past has led to him becoming the historian for Planet Paranormal. Some of Planet Paranormal's discoveries have led him to be involved with a number of television shows, including *My Ghost Story, The Dead Files* and *Ghost Hunters.* Brian was also the focus of a companion documentary for the film *Paranormal Asylum* by Meridien Films.

Brian has appeared on many radio programs, as well as giving lectures at top paranormal conventions, and he has spoken at several colleges, both in lecture and teaching capacities. He lives in Southern California with his family and pets.

Bob Davis is a commercial real estate investor by day and a paranormal researcher by night. Bob co-owns Planet Paranormal Radio, Planet Paranormal Investigations and Queen Mary Shadows, along with Caitlyn Quinn and Brian Clune. Bob lives in Southern California with his lovely wife, Miyu, and son, Nick. His daughter, Katrina, also a paranormal researcher, is currently living and investigating in Tennessee, where Planet Paranormal team members enjoy discovering new locations.

Mr. Davis has been on over thirty-five national and international radio broadcasts and featured in ten books and magazines and two documentary films.

In addition, he has been published in the *New York Daily News, World News,* the *LA Examiner* and the *Paranormal Examiner* newspapers and has been seen on such hit television shows as *Ghost Hunters, Ghost Adventures, My Ghost Story* and *The Dead Files.*

BRIAN AND BOB ARE ALSO hosts of the hit radio show *Planet Paranormal Presents,* which airs Tuesday mornings on 102.7 FM The Hog, in Kansas City, Missouri. Their show can also be found on Planet Paranormal.com.